PHOTOGRAPHY

Curtin & London, Inc. Somerville, Massachusetts **Van Nostrand Reinhold Company** New York Cincinnati Toronto Melbourne

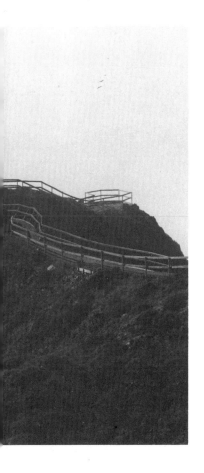

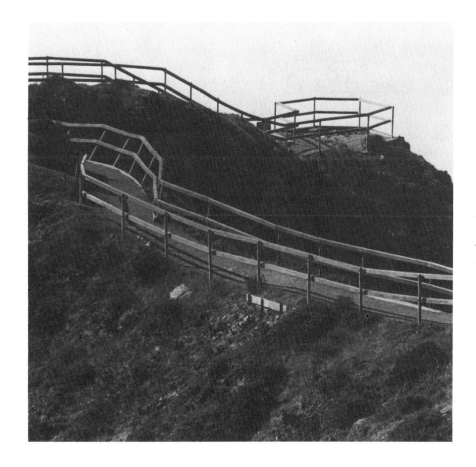

Printed in the United States of America

Published in 1981 by Curtin & London, Inc.
and Van Nostrand Reinhold Company
135 West 50th Street, New York, NY 10020, U.S.A.

Van Nostrand Reinhold Limited
1410 Birchmount Road
Scarborough, Ontario M1P 2E7, Canada

Van Nostrand Reinhold Pty. Ltd.
17 Queen Street
Mitcham, Victoria 3132, Australia

10 9 8 7 6 5 4 3 2 1

Cover design and interior design: David Ford
Cover photograph: Courtesy of Tamron Industries, Inc.
Composition: DEKR Corp.
Printing and binding: Halliday Lithograph
Cover printed by: Phoenix Color Corp.

All photographs by the author, unless otherwise credited.

Library of Congress Cataloging in Publication Data

Hawken, William R.
 Zoom lens photography.

 Includes index.
 1. Zoom lenses. 2. Photography—Handbooks, manuals, etc. I. Title.
TR270.H39 1981 771.3'52 81-3117
ISBN 0-930764-29-3 AACR2

Zoom Lens Photography

ZOOM LENS

WILLIAM R. HAWKEN

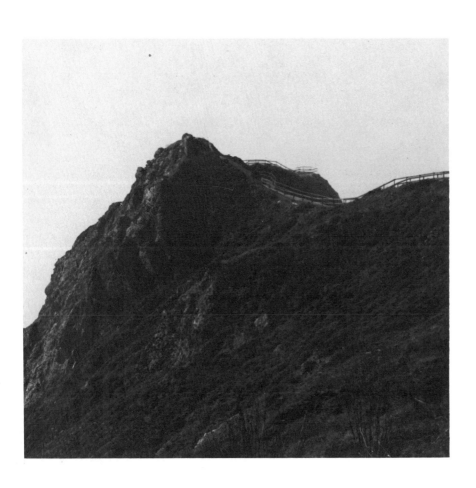

Contents

Preface

Only a few short years ago, zoom lenses for 35mm cameras were regarded as esoteric, experimental, and expensive novelties of dubious reliability. Now a new day has come. Thanks to dramatic advances in the technology of lens design and manufacture, an impressive array of high-quality zoom lenses of many focal-length ranges is offered—and at affordable prices—by a lengthy roster of companies that specialize in optical engineering.

For the first thirteen decades of the history of photography, the camera user (whether amateur or professional) who wished to increase or enhance the range of the camera's "seeing" and his or her own vision had to acquire additional lenses to cover the range from wide-angle to telephoto. Sometimes the photographer needed many lenses of different focal lengths, at no inconsiderable cost. Today's zoom lenses are the solution to this long-standing

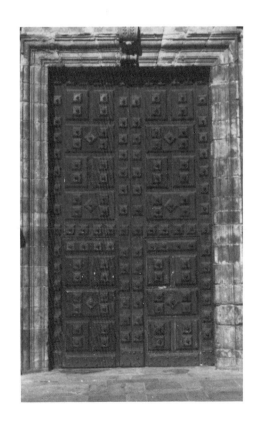

problem. A single zoom lens can do the work of a whole family of lenses with far greater convenience, efficiency, and economy. Today you can readily acquire excellent-quality zoom lenses covering a wide range of focal lengths for less than $200.

This book will describe and show by a number of illustrations how zoom lenses work, what they can do for you, and what they cannot do. While they offer many important advantages, certain limitations must also be taken into account.

In regard to the photographs used to illustrate zoom lens performance characteristics, you should note that in some cases it is possible to state the focal length used, but that in others it is not. While zoom lenses have a minimum and a maximum focal-length range, not all of the in-between focal lengths are marked on the lens barrel. In any case, when you are actually using a zoom lens to frame and photograph a subject to your satisfaction, the exact focal length you use is quite irrelevant. For example, a 75mm–205mm zoom lens can provide a range of 130 different focal lengths, if expressed in millimeters, if you simply move a ring backward or forward. Whether the focal length you use happens to be 93mm or 147mm need not be a consideration. The content of the picture is what is important.

The photograph of closed doors accompanying this preface is intended to symbolize "pre-zoom" days for most camera owners whose cameras are equipped with only a single lens of average focal length. A zoom lens is a key that will open the doors to a whole new world of both visual and photographic experience, far beyond the capabilities of any one lens having a fixed focal length. Once the

doors are open, you will find that many adventures lie ahead. This book will introduce you to what lies beyond those closed doors.

In the preparation of the book I have had the help and advice of colleagues and friends. I acknowledge my indebtedness and extend my thanks to Bridget Rivero, David Garratt, Howard White, Merri Wardenburg, Chris Williams, Paul and Jeri Westernoff, Roberto Zamora, Jerry Alan Kler, Doug Chickering, Barbara and Ralph Smith, Bernice Marlowe, and Pamela Pacula. Any errors or oversights in the book are attributable to the author.

All photographs, except for those noted, were made by the author using a variety of zoom lenses. In a number of the illustrations that show cameras, lenses, and accessories, the chance appearance of a product name is not to be construed as an endorsement.

William R. Hawken
Mill Valley, California
1981

Zoom Lens Photography

THE ZOOM LENS—WHAT IS IT?

A zoom lens, first of all, is one of the most remarkable achievements in modern phototechnology. Although immensely complicated in its optical design and mechanical construction, a zoom lens is very simple to use.

The magnifying properties of lenses were known in ancient times through the discovery of curved fragments of volcanic glass. Although unheralded then, this was the first step in the ongoing development of the science of optics, which in time was to lead to the invention of the telescope, the microscope, and other complex devices which have vastly extended the range of the human eye. At a humbler level this science gave us eyeglasses, with which defects in human vision could be corrected. High-power telescopes and microscopes, which are very costly, are within the reach of only a few, but today zoom lenses, which are relatively modest in

price and astonishingly versatile and efficient, are available to most owners of modern, high-performance 35mm single-lens-reflex cameras.

Before the advent of high-quality zoom lenses, 35mm cameras came equipped with a so-called standard or normal lens which had an angle of

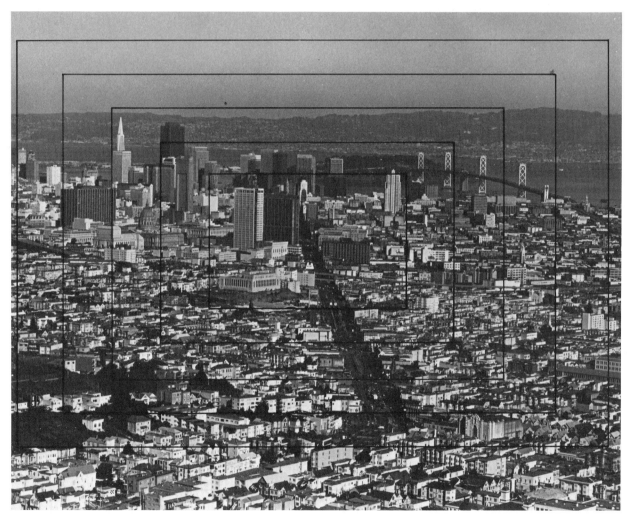

FIG. 1-1. When using a zoom lens, you can select whatever portion of a scene you wish to include.

view corresponding fairly closely to the angle of view of the human eye. Normal lenses have a focal length (lens-to-film distance) of around 50 mm to 55 mm. Lenses having a shorter focal length broaden the angle of view and are referred to as wide-angle lenses. Those having a longer focal length narrow

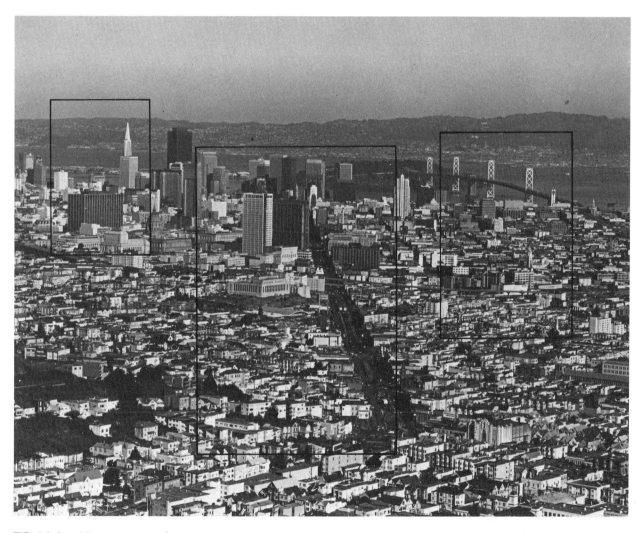

FIG. 1-2. In addition, you can alter the direction in which you point the camera and, by rotating the camera, select vertical formats from the scene.

the angle of view and are referred to as telephoto lenses.

In pre-zoom days, a photographer whose work demanded the use of lenses of different focal lengths to control the angle of view had to acquire additional lenses—interchangeable lenses, as they are called—which could be substituted for the normal lens. While interchangeable lenses have performed

FIG. 1-3. Pre-zoom days: a photographer covering action with three cameras and lenses.

well for decades, they do have three disadvantages. First, it takes time to change one camera lens to another of a different focal length. Second, an assortment of additional lenses requires quite a large investment, and adds to the bulk of the equipment a photographer has to carry. In addition, interchangeable lenses work at a fixed focal length and a fixed angle of view.

FIG. 1-4. Zoom days: one camera and one lens do the work of three cameras and more than three lenses.

Zoom lenses have overcome, in large measure, all three of these disadvantages. For example, when using a zoom lens having a focal-length range of 28 mm to 85 mm, you can instantly command changes in both focal length and angle of view without having to change lenses. You can choose any focal length you wish between the minimum and the maximum.

Consider, for example, the situation of a news photographer who has been assigned to cover a parade. He will need a wide-angle lens, a normal lens, and a telephoto lens. As the action unfolds before him, he will have no time to stop and change lenses. His only recourse is to carry three cameras, each with a different lens. Two additional cameras add still more to his equipment costs. With a zoom lens, however, he needs only a single camera.

How a Zoom Lens Works. Camera lenses consist of a series of various glass elements of different curvatures which must be positioned with extreme pre-

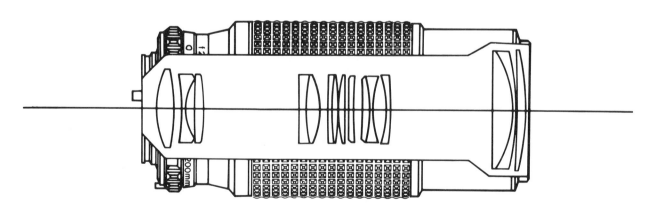

FIG. 1-5. Cross-sectional view of a typical zoom lens (80–200mm). (Courtesy of Minolta Corp.)

cision. The utmost accuracy in every step from optical design to finished product is required. In normal or interchangeable lenses, the position of the lens elements is fixed. To focus, you move the entire lens assembly farther from or nearer to the film plane. The focal length, however, remains fixed.

In a zoom lens, the spatial relationship between certain groups of lens elements can be mechanically changed. It is this optical feature that makes the alteration of the focal length of the lens possible. Figures 1-5 and 1-6 show cross sections of typical zoom lenses.

Zooming, Focusing, and Shooting. For zooming and focusing, there are two types of zoom lenses, which are designated as "one-touch" and "two-touch" lenses. With a one-touch zoom lens, you control both zooming and focusing by a single knurled ring on the lens barrel. With a two-touch zoom lens, you use two rings—one for zooming and the other for focusing.

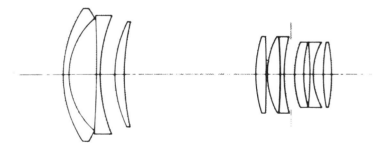

FIG. 1-6. Cross-sectional view of 35–80mm f/2.8 macro zoom lens.
(Courtesy of Tamron Industries, Inc.)

Focusing a zoom lens is no different in principle from focusing other types of camera lenses. There is, however, one important caveat. The longer the focal length of the lens you use is, the more critical focusing becomes. When you are focusing on a distant object at infinity, you encounter no problem. But when you are focusing on a nearby object, you must focus very carefully. This is because the depth of field (see Chapter 4) of a long-focus zoom lens is very shallow.

On the other hand, many long-focus zoom lenses offer an important advantage over long-focus lenses having a conventional fixed focal length. Because such lenses are designed for telephotography of distant objects, many are limited in their ability to focus on nearby objects. The minimum camera-to-subject distance may range from 12 feet to almost 30 feet, depending on the focal length of the particular lens. In comparison, a typical 205mm zoom lens may be able to "close focus" at a distance of as little as 4 feet. At this range, you can photograph very small objects. In using shorter-focal-length zoom lenses, the camera-to-subject distance can be as little as a few inches. More will be said about this in Chapter 5, which deals with close-up photography.

A further distinction in the family of zoom lenses is between what are usually called true zoom lenses and variable-focus, or varifocal, zoom lenses. True zoom lenses maintain accurate focus as you change the focal length. Varifocal zoom lenses require slight refinements in focus when you change the focal length. This cannot be considered a significant difference because the adjustment in focus is only minor. In special situations, however, such as when you are photographing high-speed action and there

is no time to refocus, the ability of a true zoom can be advantageous.

Still another difference among zoom lenses is found in the mechanics of the zoom control. Zoom lenses of the one-touch type usually have a push-pull movement to increase or decrease the focal length. Two-touch zoom lenses usually employ a ring which is rotated helically to alter the focal length. (See Figures 1-7 to 1-10.)

Another aspect of zoom lenses that is not found in conventional fixed-focal-length lenses has to do with aperture settings. A number of zoom lenses are listed as having two maximum apertures, such as f/2.5–f/3.5, f/2.8–f/3.8, f/3.5–f/4.5, and so on. Because you can change the focal length of a zoom lens at will, you cause a change in the effective

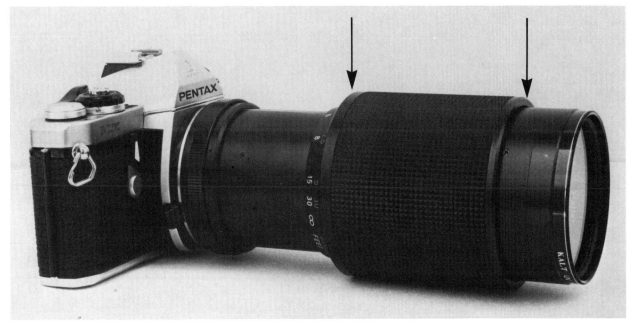

FIG. 1-7. 75–205 one-touch zoom lens with zoom focus extended for 75mm range.

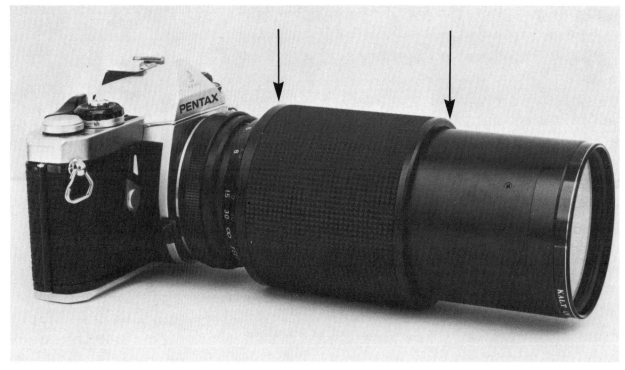

FIG. 1-8. 75–205 one-touch zoom lens
with zoom-focus ring retracted for
205mm range.

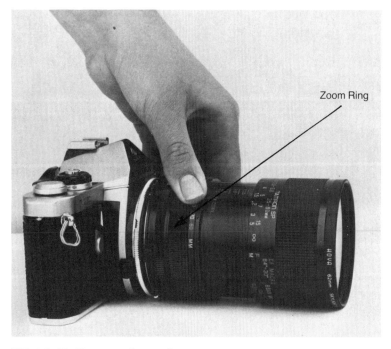

FIG. 1-9. 35–80 two-touch zoom lens.
The rear ring is the zoom ring.

aperture setting. If the maximum aperture is listed as f/3.5–f/4.5, the maximum aperture when you use the lens at its minimum focal length is f/3.5; but when you use it at its maximum focal length, the maximum aperture is f/4.5—a difference in exposure of approximately one f-stop. In cameras with built-in metering systems, the meter will indicate the required change in exposure time. If you use an off-the-camera meter, you will have to make an adjustment in exposure to accommodate the change in effective aperture.

Hand-held Pictures with Zoom Lenses. Here a cautionary note is very important. Let us suppose you are hand-holding a 50–150mm zoom lens at its minimum focal length of 50 mm and at a shutter speed and aperture setting of 1/125 of a second at f/11. If you hold the camera reasonably steady, you will get a sharp picture. However, if you extend the focal length to 150 mm, you introduce a new factor, although the subject, the lighting conditions, and the

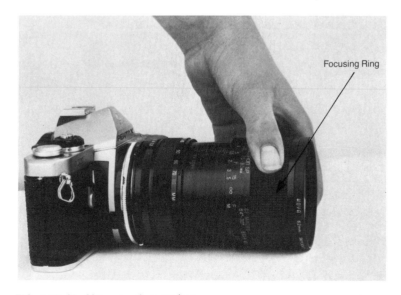

FIG. 1-10. 35–80 two-touch zoom lens. The forward ring is the focusing ring.

camera settings are the same. The image as seen through the viewfinder (and recorded by the lens) is now magnified. The important thing to bear in mind is that at the same time, any slight degree of hand or body motion also becomes magnified. The same is true of any motion of the subject. Subject or camera motion that might be imperceptible when you are using a lens at a 50mm focal length may be quite noticeable when you are using the lens at a 150mm focal-length setting.

To control camera movement when using a long focal length, use great care in bracing your body and supporting the camera. To minimize any subject movement, you might have to use a faster shutter speed—1/250, 1/500, or even 1/1000 of a second—depending upon the degree of subject motion. This will require the use of a larger lens aperture setting, which in turn will diminish depth of field. Focusing will then become increasingly critical if you are to obtain a sharp picture.

A sturdy tripod will eliminate camera movement, of course, but in situations where you must hand-hold a camera with a long-focus zoom lens, a high-speed film (ASA 400 or more) can be a decided advantage, because it allows you to use fast shutter speeds at relatively small lens apertures. The one all-important thing to keep in mind when making hand-held photographs with a long-focus zoom lens is to be very careful about camera movement. The longer the focal length of the zoom lens is, the more careful you will have to be. You cannot casually "snapshoot" with a long-focus zoom lens.

In addition to those used on cameras, zoom lenses are available for slide projectors, thus enabling the projectionist to control the size of the screen image. Work to develop zoom lenses for enlargers is also in process.

FIG. 1-11. Columns, Casa Battlo,
Barcelona, Spain. Architect: Antonio
Gaudi. 35–85mm zoom lens used at
75mm.

WHAT IS SHARPNESS?

To respond to this question in a familiar way, "That is a good question." A "good" question is often one that has more than one answer, depending upon the situation toward which the question is aimed. One can say of a photograph, "Sharp. Acceptable." Or one can say, "Not sharp. Unacceptable." But between these two extremes there is a middle ground. The evaluation of what constitutes satisfactory sharpness in a photograph is highly relative to a number of factors, and is also highly subjective. What is acceptable sharpness to one person may not be acceptable sharpness to another. In scientific photography, sharpness can be measured very accurately and expressed *quantitatively*. But for the overwhelming majority of the photographs we see or make, no precise measurement of sharpness is possible. Sharpness can only be judged *qualitatively*. The question simply comes to this: Is the pho-

tograph sufficiently sharp to serve the purpose for which it was intended? Expressed in another way, does the visual information it conveys satisfy *my* need?

In relating this question to depth of field, you may find that objects in the near foreground or distant background are not as sharp as the subject on which the camera was focused. This brings us to several factors that affect our subjective evaluation of acceptable sharpness.

First of all, there is the matter of print size, or degree of enlargement. If a 35mm negative that has an image size of 1 × 1½ inches is enlarged to 3 × 4½ inches, any lack of sharpness in near or distant objects may not be discernible to the human eye. Therefore, the print is acceptably sharp. If, however, the negative is enlarged to 10 × 15 inches, the lack of sharpness will become quite evident and perhaps disturbing. Such a print will be judged unacceptable.

A second factor has to do with viewing distance. If a 10 × 15 inch print is viewed at a distance of 12 inches, some degree of blurriness will be discernible and the print judged unacceptable. However, if the print is viewed at a distance of 12 feet, the lack of sharpness will not be discernible and the print will be judged acceptable.

Consider, for example, the case of photomurals. If you examine the sharpness of a small area of a photomural at a close viewing distance, the lack of sharpness of the image may be totally unacceptable. But to see the mural as a whole, you may find it necessary to back off to a distance of 25 feet. At this viewing distance the image appears acceptably sharp, even though it is not sharp.

Another factor is relative sharpness. The question

is, relative to what standard? Here again the "standard" is visual and subjective. Take, for example, a print that may be judged acceptably sharp but that in fact is somewhat blurred. If you then compare it with a print that is very sharp, it becomes unacceptable. The sharp print thus becomes the standard by which you rate the blurry print.

This factor of relative sharpness occurs frequently with respect to depth of field. In photographing a succession of similar objects receding into the distance, you may discover that the nearer ones, if seen in isolation from the others, appear to be acceptably sharp, but when seen in context with objects in the same scene that are quite noticeably much sharper, they lose their acceptability.

According to optical theory, there is one plane and one plane only that is at optimum sharpness. This is the plane on which the camera is focused. Anything nearer to or farther from this plane will not be perfectly sharp, but the human eye may not be capable of detecting the difference. Theoretically, near and far objects will not (strictly speaking) be in focus, but because the human eye cannot detect such differences, for all practical purposes the objects will appear to be in focus and the image will be judged acceptable.

Photographically produced images record, interpret, communicate, and express. If they succeed in performing one or more of these functions to the satisfaction of the viewer, the question of sharpness becomes unimportant. A recording photograph of a highly detailed subject will be a failure if it is not sharp, but an expressive photograph of a dancer in action that is markedly blurred may be a success. In fact, photographs of some subjects may actually be more pleasing to the viewer if they are slightly

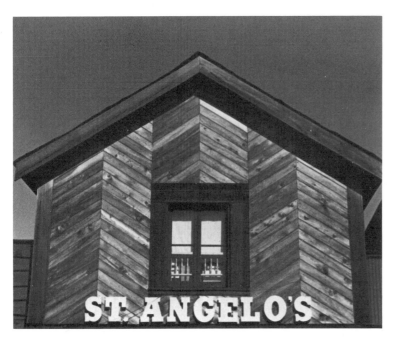

FIG. 2-1. In this photograph, every
board and knothole can be seen. Is it
"acceptably sharp"?

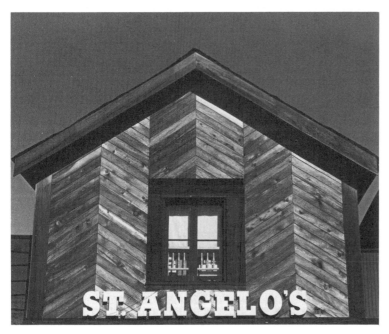

FIG. 2-2. Compare this print with
Figure 2-1. Which print is now
"acceptably sharp"?

vague. Too slow a shutter speed or a slight degree of camera movement may soften the image, creating an impressionistic effect which through the very absence of ideal sharpness conveys a feeling about the subject. Also, as shown in Figure 2-3, the deliberate use of "out-of-focus" techniques—decreasing the depth of field—can also be very useful. Sharpness, therefore, is indeed relative.

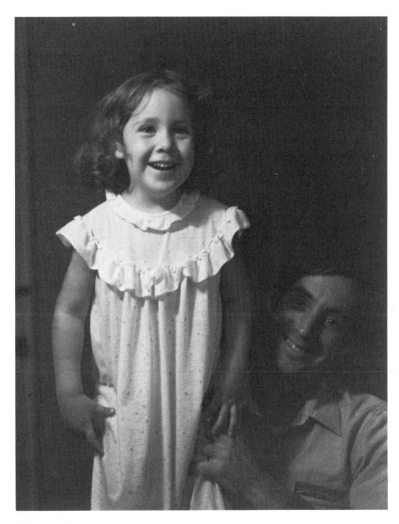

FIG. 2-3. This portrait, if examined critically, is not "needle sharp." But is it acceptable? (Photo courtesy David Garratt.)

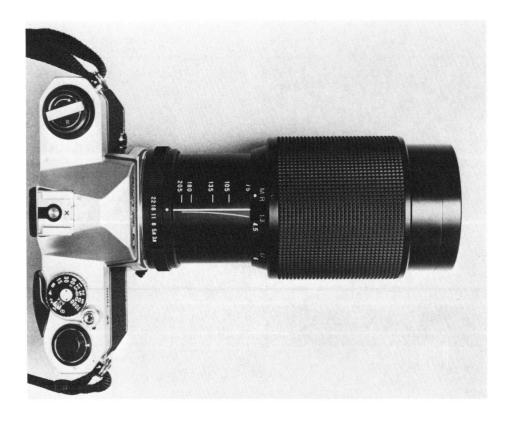

ZOOM LENS FOCAL LENGTHS

In a recent survey of zoom lenses currently being offered for sale, over 170 zoom lenses listed under 38 different trade names were found. These lenses are not all unique. Several manufacturers of zoom lenses market their products under their own trade name but also supply the same lenses to camera manufacturers, who market them under the trade name of their cameras. From the lenses on the list, a total of 65 different focal lengths are currently offered, ranging from an exclusively wide-angle zoom having a range of only 21 mm to 35 mm, to an exclusively telephoto zoom lens having a range of 135 mm to 600 mm.

A listing of the focal-length ranges of zoom lenses on the market at the present time is given in the table that follows. It would appear from the table that the preponderance of camera owners lean toward zoom lenses that have a focal-length range

from medium to long telephoto. Over half of the lenses listed range from a minimum focal length of 70 mm to 80 mm (longer than a normal lens) to a maximum focal length of 300 mm. Another numerically important group includes lenses that have both a wide-angle and a more moderate telephoto capability. A number of these have a minimum focal length of 28 mm to 35 mm and a maximum focal length of 70 mm to 100 mm.

Figure 3-1 shows the width of the field taken in by lenses of nine different focal lengths; it was made

A LISTING OF ZOOM LENSES ARRANGED ACCORDING TO MINIMUM FOCAL LENGTH (mm)

21−35	38−90 (2)	75−150 (5)
24−35	39−80	75−200 (4)
24−40	40−80 (2)	75−205 (4)
24−48	43−86	75−250
24−50	45−75	75−260 (3)
25−42	45−100	80−200 (18)
28−45	45−125	80−205 (6)
28−50 (3)	45−150 (2)	80−210 (3)
28−70 (2)	50−300	80−250 (3)
28−75	53−270	85−205 (2)
28−80 (5)	60−135	85−210 (7)
28−85 (3)	60−150	85−250
35−70 (9)	65−135	85−300 (4)
35−75	70−140 (4)	90−180
35−80 (2)	70−150 (10)	90−230 (3)
35−85 (3)	70−160	100−200 (5)
35−100 (2)	70−210 (6)	100−300 (5)
35−105 (2)	70−220 (4)	100−500
35−140	70−230	120−300
37−105 (4)	70−250	135−600
38−70 (3)	70−270	200−500
38−85	70−350	

The numbers in parentheses show the number of companies who offer lenses at these focal lengths. In addition to the maximum focal lengths shown, the range of a number of zoom lenses can be increased by means of accessory optical components. (The uses of these accessories will be discussed in Chapter 12.)

with a 28mm wide-angle zoom lens at a camera-to-subject distance of 44 feet. In the center (see inset) is the figure of a woman watching a yacht race. Figure 3-2 was made from the same vantage point—44 feet—using a long-focus zoom lens having a focal length of 410 mm.

These two figures show not only the difference in angle of view of two zoom lenses with markedly different focal lengths, but also the power of a long-focus zoom lens to record only a very small area of a scene with remarkable fidelity. In terms of image clarity, the photograph made with the 410mm zoom lens is equivalent to one produced with a normal-focal-length lens at a very short camera-to-subject distance.

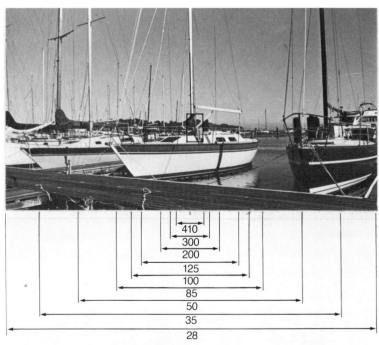

Focal Length (mm)

FIG. 3-1. Focal length vs. angle of view. Width of film: 36mm (1½ inches). Focal length: 28mm. Camera-to-subject distance: 44 feet.

FIG. 3-2. Focal length of lens: 410mm. Camera-to-subject distance: 44 feet!

Lens Mounts for Zoom Lenses. For decades the standard lens mount was of the screw-thread type. In time, a bayonet-type mount which made changing lenses easier and faster was introduced for some cameras. Today the swing appears to be entirely toward new and improved bayonet mounts, and many lenses that originally had screw-thread mounts are now being manufactured with bayonet mounts. Nonetheless, there are thousands of screw-thread mount cameras, and zoom lens manufacturers are well aware of this. In some cases you can use adapter rings if the camera mount and the lens mount are incompatible. Still, not all zoom lenses can be fitted on all cameras.

One type of bayonet mount that has become very popular is the so-called K mount, which is far more efficient than the screw-thread type. In a comparison test between the two systems, it was found that a screw-thread lens had to be rotated completely (360°) three times to disengage the lens from the camera body. To mount a replacement lens, the photographer had to follow the same procedure in reverse. The total time required to make the change was approximately 30 seconds. In removing and replacing K mount lenses, the photographer needed to turn the lens only about 1/6 of a turn. The total time required to make this change was approximately 8 seconds.

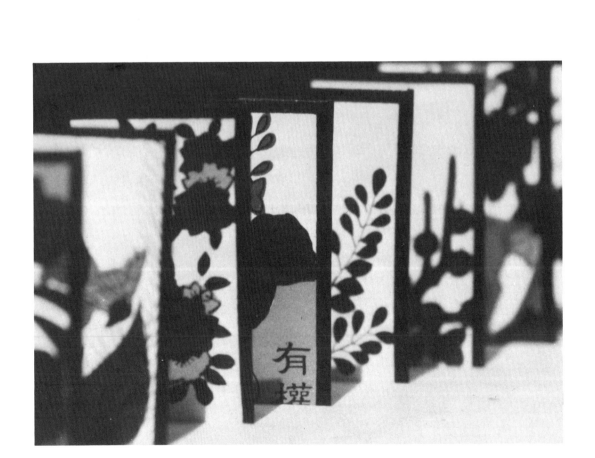

DEPTH OF FIELD

With all camera lenses, depth of field—which is to say, how much in distance will be in focus—involves three interrelated variables, each of which must be understood and taken into account:

The focal length of the lens.
The camera-to-subject distance.
The lens aperture setting.

The following six rules are especially important to remember when you are using zoom lenses.

1. The *shorter* the focal length of the lens, the *greater* the depth of field will be.

2. The *longer* the focal length of the lens, the *shallower* the depth of field will be.

3. The *greater* the camera-to-subject distance, the *greater* the depth of field will be.

4. The *shorter* the camera-to-subject distance, the *shallower* the depth of field will be.

5. The *smaller* the lens aperture setting, the *greater* the depth of field will be.

6. The *larger* the lens aperture setting, the *shallower* the depth of field will be. (Note that the lens aperture setting numbers run in reverse order. The *larger* the number, the *smaller* the opening.)

A model using counters from a Japanese game called Hanafura was constructed for the following eight photographs. (See Figures 4-1 to 4-8.) Each of the counters or chips measures 1¼ × 2. The entire model is 28 inches long. This small-scale model was deliberately chosen because gains and losses in depth of field are much more apparent when you are working at a close camera-to-subject distance. The photographs thus serve to illustrate in an exaggerated form the basic principles governing depth of field and its three variables. Data on the focal length, the camera-to-subject distance, and the lens aperture setting are provided in the captions.

Each of the pairs of photographs shows quite clearly the difference in depth of field when you set the lens at a large aperture or a small aperture. The use of a lens aperture setting between the minimum and the maximum shown will yield an intermediate degree of depth of field. Other points, however, are important to note.

1. For Figures 4-1 and 4-2, the photographer used a normal lens (50 mm) at close range (28 inches). As is shown in Figure 4-2, depth of field is considerable if you use a small lens aperture (f/16). Despite the relatively short camera-to-subject distance, depth of field has been achieved in accordance with rule 1—

the shorter the focal length of the lens, the greater the depth of field will be—and rule 5—*the smaller the lens aperture setting, the greater the depth of field will be.*

2. For Figures 4-3 and 4-4, the photographer used a 100mm zoom lens, but because of its longer focal length the camera-to-subject distance was increased to 48 inches. This is still working at relatively close range, considering that the near and far counters in the model are 28 inches apart. These photographs illustrate the relationship between rules 2 and 4: *The longer the focal length of the lens, the shallower the depth of field will be*, and *the shorter the camera-to-subject distance, the shallower the depth of field will be.* Although the camera-to-subject distance was increased to 48 inches, this proved to be insufficient for a lens having a focal length of 100 mm, even at a small lens aperture (f/16).

3. For Figures 4-5 and 4-6 the photographer used a focal length of 200 mm. To include the entire model, the camera-to-subject distance had to be increased to 70 inches (approximately 6 feet). Two things should be noted. Despite an increase in camera-to-subject distance, depth of field is extremely limited if you use a large lens aperture (f/3.8). Only the single counter focused on in the center is sharp. By using a small lens aperture, you increase depth of field, but insufficiently to achieve overall sharpness. Your only recourse would be to increase the camera-to-subject distance substantially. This would result in a smaller image on film, but one that would be sharp.

4. A similar situation is demonstrated in Figures 4-7 and 4-8. For these examples, the photographer

used a focal length of 300 mm and increased the camera-to-subject distance to 86 inches (more than 7 feet). Depth of field is somewhat improved by this increase, but this advantage is overridden by the longer focal length of the lens.

With the three principles now in mind, we can

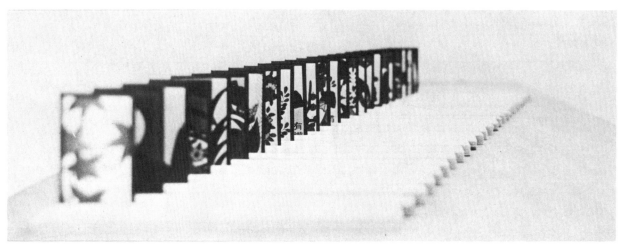

FIG. 4-1. Lens focal length: 50 mm.
Camera-to-subject distance: 28
inches. Lens aperture: f/3.5.

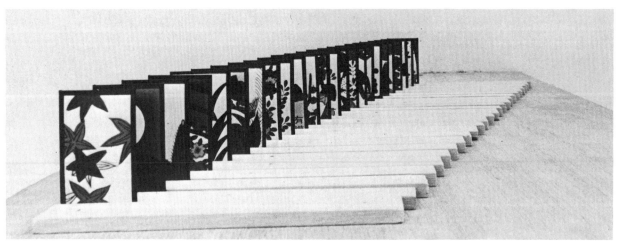

FIG. 4-2. Lens focal length: 50 mm.
Camera-to-subject distance: 28
inches. Lens aperture: f/16.

consider further characteristics of lens performance in relation to depth of field.

When using conventional interchangeable lenses having only a single focal length, you can make a fair approximation of what the depth of field would be at a given camera-to-subject distance and at a

FIG. 4-3. Lens focal length: 100 mm. Camera-to-subject distance: 48 inches. Lens aperture: f/3.8.

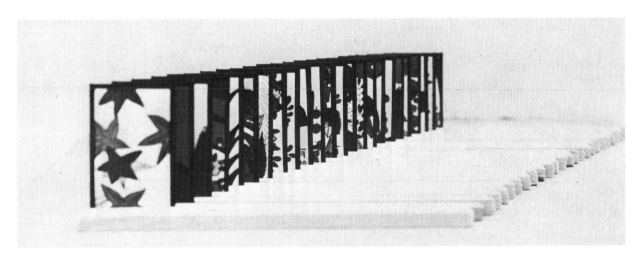

FIG. 4-4. Lens focal length: 100 mm. Camera-to-subject distance: 48 inches. Lens aperture: f/16.

given lens aperture by reading a depth-of-field scale engraved on the lens barrel. With the lens focused on an object at a certain distance, the scale will indicate the near and far planes between which objects will be in focus. This method is only approximate because the lens designer has only a limited amount of space in which to engrave the camera-

FIG. 4-5. Lens focal length: 200 mm.
Camera-to-subject distance: 70
inches. Lens aperture: f/3.8.

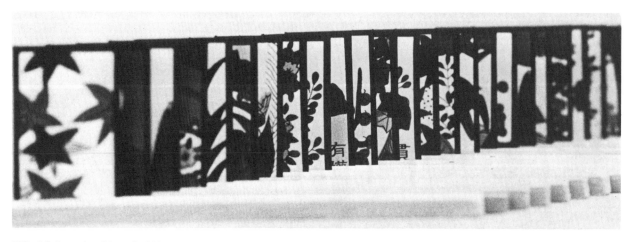

FIG. 4-6. Lens focal length: 200 mm.
Camera-to-subject distance: 70
inches. Lens aperture: f/16.

to-subject distance numbers. A typical scale on a 50mm lens may show markings only for 6, 8, 12, and 25 feet, and infinity. In meters, the scale reads 1, 2, 3, 5, 15, and infinity. You have to guess at in-between distances. For example, with a 50mm lens focused on an object 12 feet away, the depth-of-field scale will show that at an aperture of f/11, objects

FIG. 4-7. Lens focal length: 300 mm. Camera-to-subject distance: 86 inches. Lens aperture: f/3.8.

FIG. 4-8. Lens focal length: 300 mm. Camera-to-subject distance: 86 inches. Lens aperture: f/16.

from approximately 8 to 20 feet will be in focus. At an aperture of f/22, objects from approximately 6 feet to infinity will be in focus. The incorporation of a depth-of-field scale on conventional lenses is possible for one reason: they operate at one fixed focal length.

With zoom lenses, the situation is considerably different. A typical 35–85mm zoom lens has fifty different focal lengths, in millimeters. Because every change in focal length alters depth of field (rules 1 and 2), ideally such a lens should have fifty depth-of-field scales. This, of course, is an impossibility. The available space on the barrel of a lens is simply too limited for such a vast set of numbers. To compensate for this lack of space, zoom lens designers often employ a curving set of lines converging on the distance scale; but again, because of space limitations they can include lines for only a few focal lengths. A typical lens might have lines for focal lengths of 35 mm, 50 mm, and 85 mm. You can only approximate the depth of field for in-between focal lengths by guesswork. Nonetheless, although limited, these scales can be quite helpful as indicators of approximate depth of field.

A more precise source of depth-of-field information for different camera-to-subject distances, different focal lengths, and different lens apertures is given in the depth-of-field tables printed in the owner's manual that accompanies a zoom lens. These tables give near and far planes in decimal fractions of a foot or a meter. Although highly accurate, these tables are also limited because they include only certain specific camera-to-subject distances and only certain focal lengths. You again must guess at in-between settings of both distance and focal length.

Depth-of-field tables of a 45–125mm zoom lens are shown in Figures 4-9 and 4-10. Note that the two

FIGURE 4-9 DISTANCE SCALE SET AT 45 mm

Distance / Aperture	1.5 m	2 m	3 m	4 m	5 m	7 m	10 m	30 m	∞
f/4	1.41 ~1.61	1.82 ~2.23	2.58 ~3.61	3.26 ~5.24	3.87 ~7.19	4.93 ~12.5	6.20 ~27.8	10.3 ~∞	15.5 ~∞
f/5.6	1.37 ~1.66	1.76 ~2.34	2.45 ~3.95	3.04 ~6.01	3.56 ~8.77	4.42 ~18.4	5.4 ~106	8.2 ~∞	11 ~∞
f/8	1.33 ~1.75	1.68 ~2.53	2.28 ~4.60	2.77 ~7.76	3.18 ~13.2	3.84 ~68.5	4.55 ~∞	6.4 ~∞	7.9 ~∞
f/11	1.27 ~1.87	1.59 ~2.83	2.10 ~5.83	2.50 12.4	2.82 38.6	3.3 ~∞	3.8 ~∞	5.0 ~∞	5.9 ~∞
f/16	1.20 ~2.14	1.46 ~3.59	1.86 ~10.98	2.16 ~∞	2.39 ~∞	2.7 ~∞	3.0 ~∞	3.7 ~∞	4.1 ~∞
f/22	1.12 ~2.60	1.34 ~5.35	1.65 ~∞	1.87 ~∞	2.03 ~∞	2.25 ~∞	2.5 ~∞	2.85 ~∞	3.1 ~∞

(d = 0.035 mm)

FIGURE 4-10 DISTANCE SCALE SET AT 125 mm

Distance / Aperture	1.5 m	2 m	3 m	4 m	5 m	7 m	10 m	30 m	∞
f/4	1.49 ~1.52	1.97 ~2.03	2.93 ~3.07	3.87 ~4.14	4.8 ~5.22	6.6 ~7.45	9.2 ~11.0	23.6 ~41.3	108. ~∞
f/5.6	1.48 ~1.52	1.96 ~2.04	2.91 ~3.1	3.83 ~4.19	4.72 ~5.31	6.46 ~7.65	8.9 ~11.4	21.7 ~48.7	77.5 ~∞
f/8	1.46 ~1.54	1.95 ~2.06	2.87 ~3.15	3.76 ~4.28	4.62 ~5.46	6.25 ~7.97	8.51 ~12.15	19.4 ~66.6	54.3 ~∞
f/11	1.45 ~1.56	1.93 ~2.08	2.82 ~3.21	3.67 ~4.40	4.49 ~5.66	6.01 ~8.4	8.06 ~13.2	17.2 ~123	39.5 ~∞
f/16	1.45 ~1.56	1.89 ~2.12	2.75 ~3.31	3.54 ~4.61	4.29 ~6.02	5.65 ~9.26	7.41 ~15.5	14.4 ~∞	27.3 ~∞
f/22	1.43 ~1.59	1.86 ~2.17	2.66 ~3.45	3.40 ~4.89	4.08 ~6.52	5.27 ~10.5	6.77 ~19.7	12.1 ~∞	19.9 ~∞

(d = 0.035 mm)

tables show depth of field *only* for the minimum focal length (45 mm) and the maximum focal length (125 mm), with no data on in-between focal lengths.

Another widely used method for ascertaining approximate depth of field is by means of a depth-of-field preview lever or button. This disengages the lens diaphragm from its automatic mode to a manual mode. When the lens is set for automatic, you view and focus your subject with the lens at its largest aperture and hence at the minimum depth of field. When the lens is set on manual, you can view the subject at the actual aperture you will use for making the exposure. You can thus see, to some extent, what the available depth of field will be, and you can make changes in the aperture setting if needed. This method, however, has one disadvantage. As you close down the lens aperture to successively smaller openings, the light reaching your eye through the viewfinder becomes dimmer and dimmer. In shade or dim light conditions, details at the near and far planes may be too dark for you to perceive clearly. (See Figure 4-11.)

Many zoom lenses do not have a mechanism for previewing depth of field, but some cameras have

FIG. 4-11. When you use a depth-of-field preview device to determine depth of field at progressively smaller apertures, the image in the viewfinder becomes progressively darker. Details thus become difficult to discern clearly.

a button or lever on the camera body that will per-form this function regardless of the type of lens mounted on the camera.

When you are in doubt about depth of field, it is best to use the smallest possible lens aperture.

Hyperfocal Distance. The hyperfocal distance is the distance at which you can set a camera to include infinity at the far plane of sharpness and the near plane of sharpness as close to the camera as any given lens aperture will permit. With conventional lenses, you can easily determine the hyperfocal dis-tance from the depth-of-field scale, because such lenses have only a single focal length. With zoom lenses, however, with their multiplicity of focal lengths, it is not so easy to determine the hyperfocal distance for any particular lens aperture *and* any focal length you choose. However, the depth-of-field tables in the manual accompanying your lens do show combinations of distance focused on and lens aperture settings needed to bring infinity into focus.

There is another side to the depth-of-field coin. Because a long-focus zoom lens has shallower depth of field than a shorter-focal-length lens, in some situations the very lack of depth of field can be advantageous. For example, in photographing a person against a background which would be distracting if it were in focus, you can use a large lens aperture with its shallow depth of field to throw the background completely out of focus, so that the subject becomes sharply defined against a very dif-fuse background. (See Figures 4-12 and 4-13.)

Further aspects of depth of field will be discussed in Chapter 5 on close-up (macro) photography.

FIG. 4-12. Informal portrait taken
against a cluttered background with a
normal lens.

FIG. 4-13. By using a zoom lens at the same camera-to-subject distance, you can "select" the subject out of the background. Because of the shallowness of the depth of field, the background becomes a soft blur against which the subject stands out strongly.

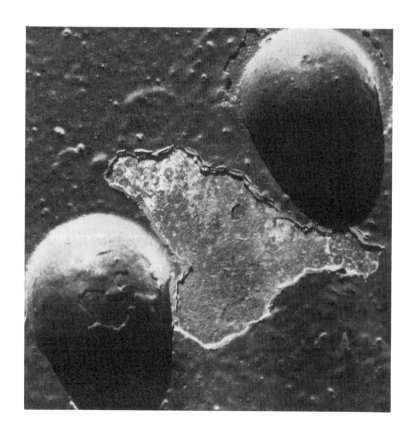

CLOSE UP

When you are using conventional interchangeable lenses of fixed focal lengths, you can best accomplish close-up photography by means of special "macro" lenses which permit you to focus at very short camera-to-subject distances. The normal lens that is standard equipment on most cameras may focus as close as 15 inches, but not much closer. To make close-up photographs with a normal lens, you must use various accessories such as supplementary lenses, extension tubes, or bellows units.

An ever-increasing number of zoom lenses of various focal lengths, called macro zoom lenses, are appearing on the market. Macro zoom lenses make it possible to do close-up photography without using accessories. This alone is a considerable advantage. A macro zoom lens thus has all the desirable features of regular zoom lenses *plus* the ability to move almost instantaneously into the world of close-up photography.

Another advantage that long-focus macro zoom lenses offer has to do with camera-to-subject distance. With short-focal-length macro lenses, you have to "be on top of your subject," so to speak. The working distance between camera and subject is extremely short. If the light is coming from behind, your shadow may be cast on the subject. When you are working with a long-focus macro zoom lens, the working distance can be as much as 3 or 4 feet, rather than a few inches. This permits you to use supplementary lighting such as floodlights or electronic flash. A long-focus macro zoom lens thus functions as a telephoto lens working at very close range. Instead of having to approach within inches or your subject, you can bring even a small subject to you by using a long-focus macro zoom lens. (See Figures 5-1 and 5-2.)

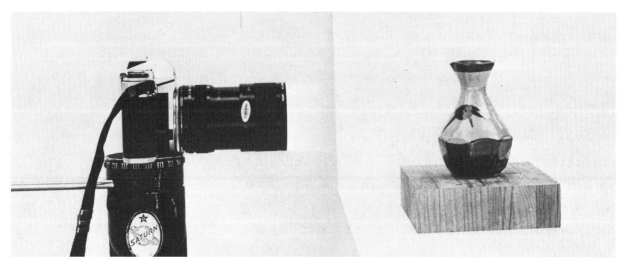

FIG. 5-1. Close-up photography with a 35–80mm macro zoom lens.

FIELD SIZE

When using a zoom lens to photograph a broad landscape, you can encompass a field that might be dozens of miles across and hundreds or even thousands of feet in height. But with a macro zoom lens, you can reduce the field size at your command to as little as a few square inches. To illustrate this, the photographer has used a playing card that measures 2¼ × 3½ in several of the photographs that follow. (See Figures 5-3 through 5-10.)

In making photographs with a macro zoom lens, you must keep two important factors in mind.

1. Depth of Field. Rule 4 under "Depth of Field" states that the shorter the camera-to-subject distance, the shallower the depth of field will be. In macrophotography, the camera-to-subject distance can be very short indeed, and depth of field can be extremely shallow. Using a long-focus macro zoom lens to increase the working distance does not ame-

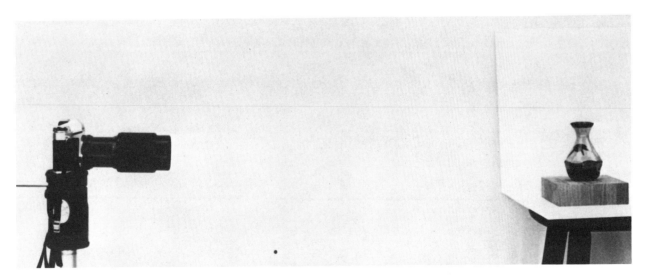

FIG. 5-2. Close-up photography with a 75–205mm macro zoom lens. Note the greater camera-to-subject distance.

FIG. 5-3. Image size on film (contact print from negative): 1 × 1½.

FIG. 5-4. Image enlarged to life size: 2¼ × 3½.

FIG. 5-5. Image enlarged to
approximately two times life size: 4½
× 7.

FIG. 5-6. Enlarging a macro image: to life size.

FIG. 5-7. Enlarging a macro image: a portion of the negative enlarged to three times life size.

liorate the problem because rule 2—the longer the focal length of the lens, the shallower the depth of field will be—goes into force. Examples of depth-of-field problems are shown in some of the illustrations that follow.

One very useful technique to increase depth of field is to increase the camera-to-subject distance somewhat. This will result in a smaller image on film, but you can usually compensate for this by increasing the degree of enlargement. The result will be a sharp overall image. (See Figures 5-11 through 5-14.)

2. *Focusing*. Because of depth-of-field limitations, you must focus very carefully and precisely. When working at a camera-to-subject distance of several feet, you can tolerate some degree of error in critical focusing because the greater depth of field will compensate for it. In macrophotography, you cannot tolerate any errors in focusing.

Because of the remarkable details that macrophotographs can reveal, it is also important that you avoid the slightest movement of the camera or the subject. You should use a tripod and cable release for ideal results. You can make hand-held macrophotographs, but you must use fast shutter speeds to eliminate any unsteadiness of the camera and any vibration effects within the camera itself.

A very slight degree of subject motion is tolerable—for example, a flower lightly touched by a breeze—if the shutter speed is fast enough to stop the action. But for the sharpest and most satisfying results, the subject you are trying to photograph should be completely motionless.

There is one more aspect of macrophotography,

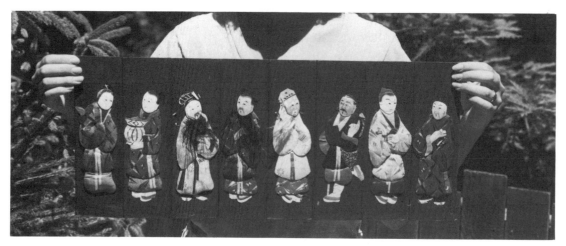

FIG. 5-8. A miniature eight-part
Chinese screen, photographed with a
35—80mm macro zoom lens. (The
model's hands show the scale of the
subject.)

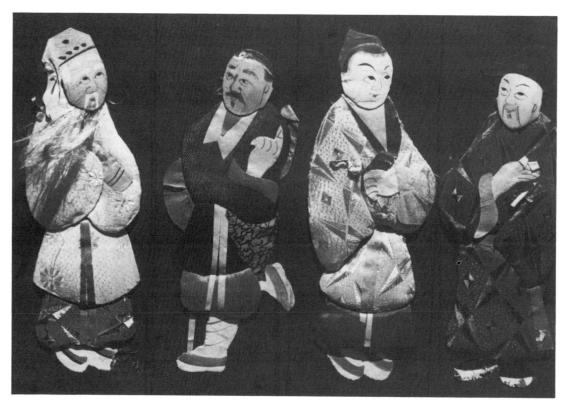

FIG. 5-9. Four of the eight panels of
the screen photographed at closer
range.

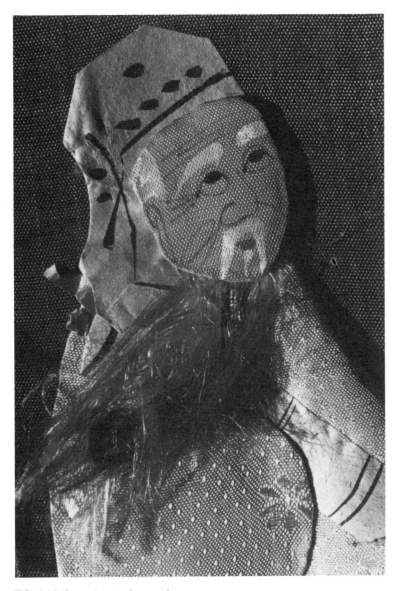

FIG. 5-10. Part of a single panel
photographed with the macro zoom at
its closest range. Note the
extraordinary detail the lens reveals.

which we can call image enhancement. If, say, you photograph a 2 × 3 inch area of a subject and from the negative make a 2 × 3 inch print, the print will be life-sized. The ratio in size between the original and the print will be 1:1. But in enlarging from a negative, you are not limited to this ratio. By increasing the size of the enlargement, you are able

FIG. 5-11. Lack of depth of field when photographing at close range.

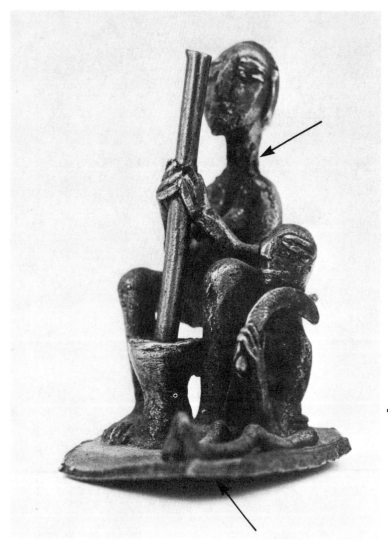

FIG. 5-12. Miniature brass sculpture photographed at too little distance for adequate depth of field. Both near planes and far planes are out of focus (see arrows).

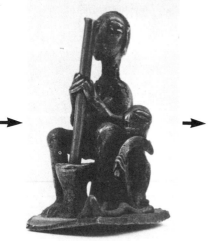

FIG. 5-13. Life-sized image of the sculpture taken at a greater camera-to-subject distance in order to increase depth of field.

to make a print much larger than life size. A macro zoom lens (or, for that matter, any macro lens) thus can function as a low-power microscope. Because of the enhancement of the size of the original image, you can reveal fine details imperceptible to the un-aided eye.

This capability for enhancing the size of a small

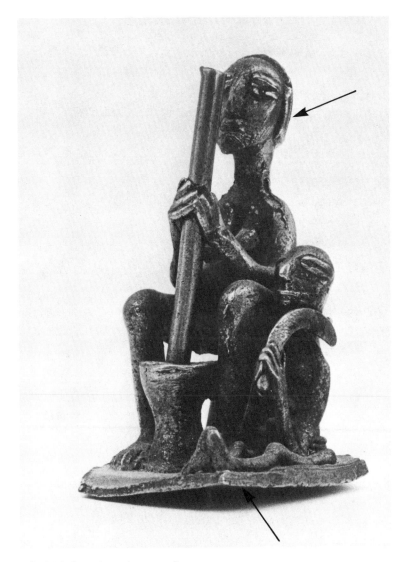

FIG. 5-14. An enlarged image of Figure 5-13. The near and far planes of the subject are now sharp (see arrows).

original can be one of the most interesting and rewarding aspects of macrophotography. A color slide, for example, of a 2 × 3 inch subject, when projected to a size of 2 × 3 *feet*, can be very dramatic indeed.

EXPOSURE DETERMINATION FOR MACRO PHOTOGRAPHY

Because you must extend the lens by means of its focusing ring in order to work at very short camera-to-subject distances, you reduce the light-gathering power of the lens. For example, if you photograph a 2 × 3 inch area on a frame of 35mm film which measures 1 × 1½ inches, the image on film will be one-half the size of the original. To compensate for the diminished light reaching the film, you will require an increase in exposure of two times—one full f-stop. To photograph an area 5 × 7½ inches, you will require an increase in exposure of one-half an f-stop. To photograph an area 10 × 15 inches in size, no increase in exposure will be needed. If you use an automatic camera which sets itself in accordance with the amount of light, the camera will make these adjustments in exposure for you.

REPRODUCTION RATIO

In advertisements for macro zoom lenses, manufacturers usually state the reproduction ratio at the closest working distance. A certain lens, for example, can operate at a ratio of 2:1. These numbers mean that the image on the negative will be one-half life size. But in making an enlarged print from such a

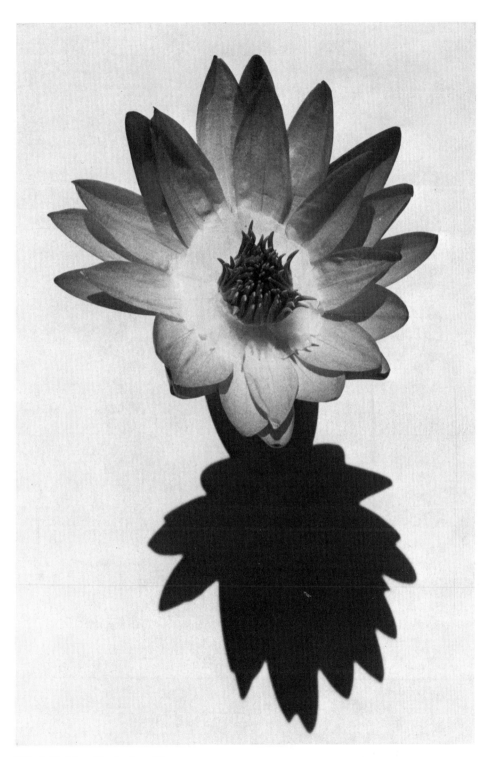

FIG. 5-15. Lily with shadow (life-sized).

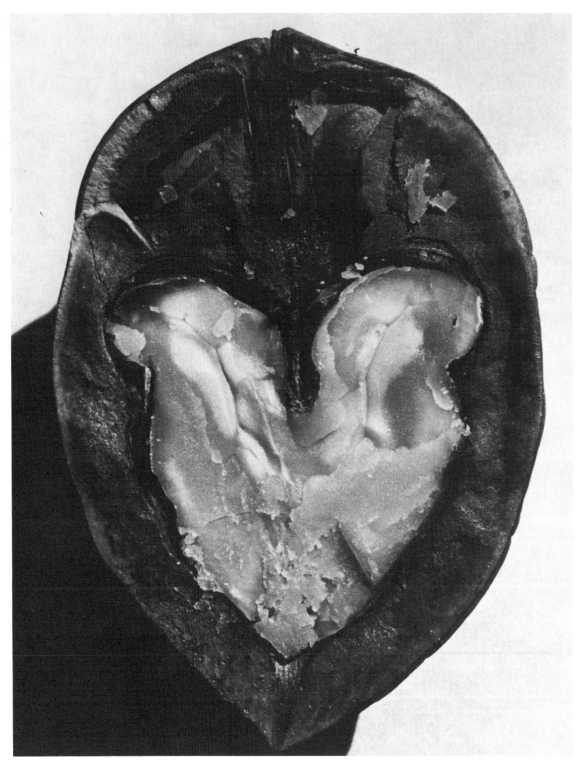

FIG. 5-16. Half a walnut in its shell,
photographed at a distance of 5
inches with a macro zoom lens.

negative, you can easily exceed a life-sized image by quite a large factor. In the photograph of the walnut half (Figure 5-16), the actual height of the walnut is 1¾ inches. The height of the image on film at a ratio of 2:1 is ⅞ of an inch. But the enlarged print from this negative is more than four times life size, thus revealing details the eye cannot see.

At least one company makes a reverse adapter for one of its zoom lenses, which makes it possible to mount the lens backward on the camera. The front end of the lens thus becomes the rear end. The purpose of a reverse adapter is to shorten the camera-to-subject distance still further for close-up work. The manufacturer makes clear certain limitations that you will encounter when you use this accessory, however. The statement in an advertisement reads:

For the most economical 1:2 reproduction, get yourself a [reverse adapter] ring and reverse the lens on your camera. As with any normal or telephoto lens used in the reverse position, the resulting shots will have some softness toward the edges of the frame (field curvature). This can be used to separate the subject in the center of the frame from its background.

Thus, one can gain in close-up ratio but lose in flatness of field and hence in overall sharpness.

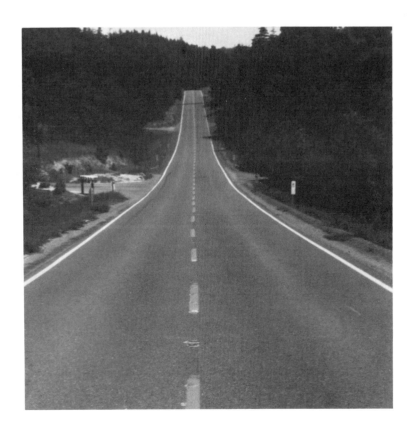

PERSPECTIVE: ANGLE OF VIEW PLUS FOCAL LENGTH

In the science of physics there is a fundamental axiom that states that parallel lines cannot converge. Albert Einstein upset this idea in his theory of relativity, but for all practical purposes it remains true, except in visual terms. Parallel lines do *seem* to converge. Whether seen by the human eye or by the eye of a camera, parallel lines, if extended far enough, will reach a vanishing point where they apparently touch.

In photography, if you point a camera toward a subject made up of parallel lines at an angle that is perpendicular to the subject, the lines will appear as the eye sees them—parallel to each other. But if you then change the position of the camera so that it views the subject at successively sharper angles, departing from the "straight-on" perpendicular, the convergence of parallel lines becomes increasingly evident. If the camera angle is extremely acute, line

convergence becomes extreme. Known rectangles become parallelograms which, if a vanishing point is reached, will become triangles. This apparent discrepancy or error in our vision is corrected by our brain, which knows that planks on the side of a building are in fact of the same width, are rectangular, and are parallel to each other, despite the visual evidence of the camera lens, which seems to prove conclusively that this is not so.

These seemingly commonplace observations about the apparent convergence of parallel lines may appear at first to be obvious and simplistic, but it is very important for you to understand the factors involved if you want to use a zoom lens skillfully. It is a mistake to assume that when you are zooming in on a subject, everything will remain the same except the area you select. A radical increase in focal length changes the rules of the game and alters the composition and content of the picture. Figures 6-1 to 6-11 show that when you change the focal length of a zoom lens, other factors also change. Depth of field is markedly reduced as focal length is increased. Changes in exposure may also be required. But the effect of changes in spatial relationships will be the most noticeable of all.

The effects of focal length and camera angle on *line* convergence are quite obvious, but when you use a long focal-length setting, another factor enters: *space* convergence. When you use a short focal-length setting, the distance between equally spaced objects appears to expand. What is only moderately distant appears in the photograph to be far away. When you use a very long focal-length setting, the opposite occurs. The distance between equally spaced objects becomes compressed, as if they had moved closer to each other. Objects known

to be at a considerable distance from each other appear to have become bunched together, with very little distance between them. A distant object that appears to be very small when you use a short focal-length setting looms very much larger and appears nearer when you use a long focal-length setting.

While the angle of line convergence does not change as you increase focal length, the compression of spatial relationships will change in proportion to the focal length you use. The most noticeable change when you are working at a relatively short

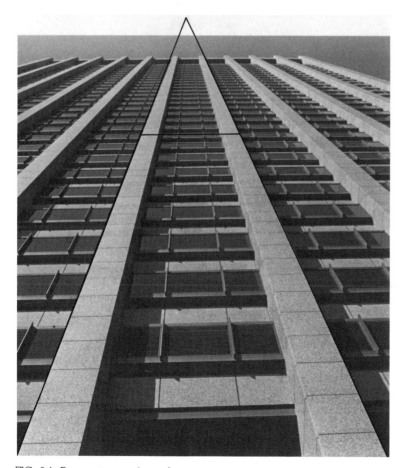

FIG. 6-1. Perspective as shown by a normal lens. The parallel vertical lines converge toward a vanishing point.

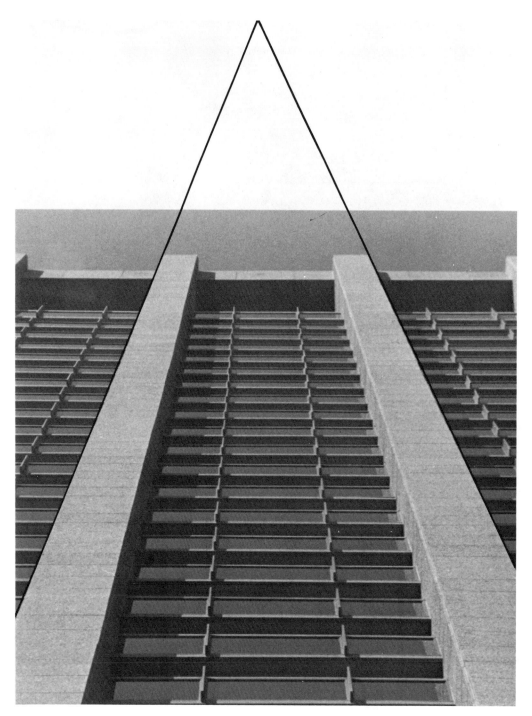

FIG. 6-2. Perspective as shown when
you use a long-focus zoom lens. Note
that the perspective is the same as in
Figure 6-1; only the content has
changed. The content of this figure is
shown in the marked triangle in
Figure 6-1.

distance will be the decided decrease of depth of field when you use a long focal-length setting. To achieve adequate depth of field, you may require a much smaller lens aperture. This in turn will require a slower shutter speed—slow enough, perhaps, to rule out the possibility of making a hand-held picture. The very extension of a lens to a long focal length will in itself change the effective lens aperture, thus requiring a still longer exposure interval.

You can thus see that the relative size of near or distant objects, line convergence, space compression, depth of field, and even exposure are interrelated and must be taken into account when you are using zoom lenses that have a long focal-length range.

Because the mind tends to "correct" a visual event in terms of what it knows about size and spatial relationships, the illustrations here are accompanied by diagrams to show the difference between what we know and what we see—between mental truth and visual truth. When you are using a zoom lens on a camera, try to see as the lens sees, not as the mind sees.

The accompanying illustrations show how both angle of view and focal length can have decided effects on the rendering of perspective. When you use a wide-angle lens having a short focal length, you can expand space. Distant objects appear to be at a greater distance and hence appear to be smaller. When you use a long-focal-length lens setting, space becomes contracted. Near and distant objects become compressed, and their apparent size relationship is altered. In addition, the longer the focal-length setting you use, the more critical the problem of depth of field will become if the camera-to-subject distance is relatively short.

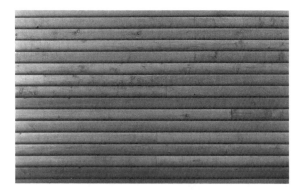

FIG. 6-3. Camera perpendicular to subject. Lines are parallel.

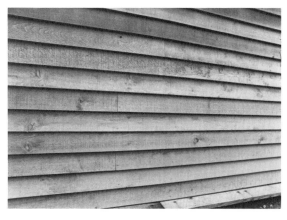

FIG. 6-4. Camera at a slight angle to subject. Line convergence becomes evident.

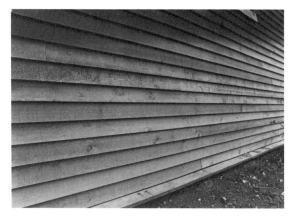
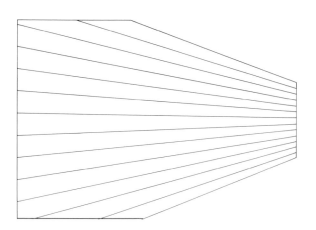

FIG. 6-5. Camera at an increased angle to subject. Line convergence increases.

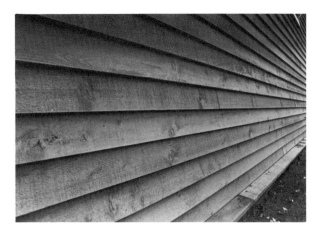

FIG. 6-6. Camera at a still greater
increase in angle. Line convergence
is very evident.

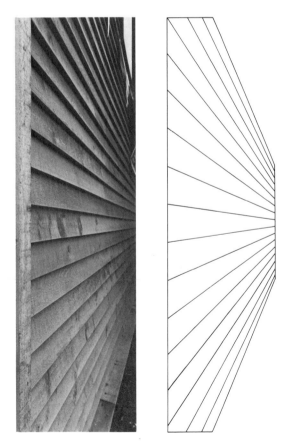

FIG. 6-7. Camera at a very acute
angle to subject. Line convergence is
marked.

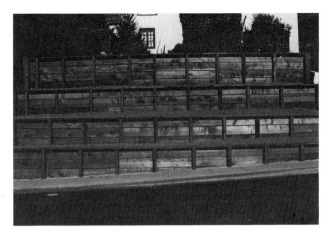

FIG. 6-8. A redwood retaining wall.
Note that the posts are vertical and
the spaces between them are
horizontal rectangles.

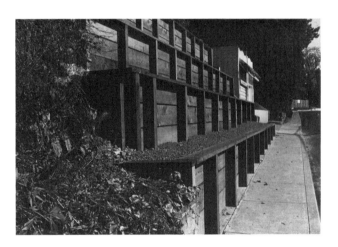

FIG. 6-9. The retaining wall
photographed with a wide-angle
zoom lens at an acute angle. Note
that the horizontal shapes between
the posts are now vertical shapes.
Space has been expanded as the
parallel lines recede toward a
vanishing point. Note in particular
that depth of field is satisfactory from
foreground to background.

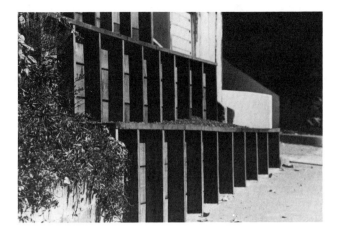

FIG. 6-10. For this photograph a
205mm focal length was used.
Compression of space now becomes
quite noticeable. The rectangular
shapes between the posts have
become very narrow. Also, a loss of
depth of field is quite apparent.

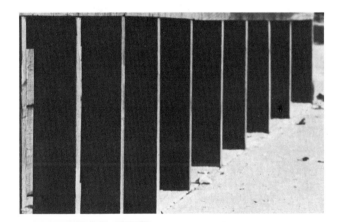

FIG. 6-11. For this photograph, a
410mm focal length was used (205mm
lens setting plus a 2X tele-extender).
The compression of space has caused
the rectangular spaces to disappear.
The posts now appear to be bunched
together instead of widely separated.
The loss of depth of field is very
evident. When working at a moderate
distance with such a long focal
length, you will find that depth of
field is extremely shallow, even at the
smallest lens aperture.

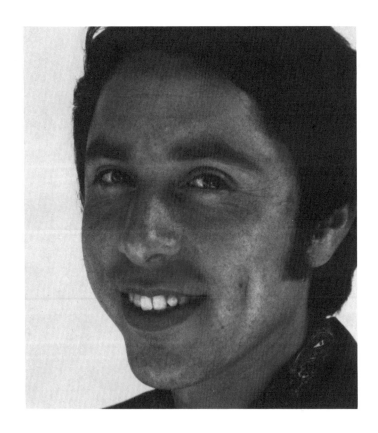

PORTRAITURE

Portraiture—pictures of people, whether done formally, informally, singly, or in groups—is by far the most popular use to which the camera has been put since it was first invented. If one of your preferences in your camera work is the photographing of people, zoom lenses offer considerable advantages over conventional lenses. You can easily vary the subject content and composition of pictures of people to suit your purpose or your taste.

One of the advantages of using zoom lenses for portraiture derives from their longer focal length. If, for example, you wish to make a full head portrait with a normal-focal-length lens, you have to work at a very close camera-to-subject distance. This involves not only technical problems but psychological problems as well. Few people can feel at ease for a portrait when the camera is thrust almost into their faces. (See Figure 7-1.) Also, when you are

working at close range with a relatively short-focal-length lens, a certain amount of feature distortion may enter. On the other hand, if you use a zoom lens having a focal length of, say, 200 mm, you can establish a much greater and more comfortable working distance between yourself and your subject. The subject can feel more at ease. The greater physical distance thus creates psychic distance. The subject can now feel that he or she is being photographed, not assassinated! At the same time, the problem of feature distortion is eliminated. (See Figures 7-2 and 7-3.) Also, when photographing a scene that includes more than one person, you can zoom in to select the one person you wish to photograph.

Because of the relatively long camera-to-subject

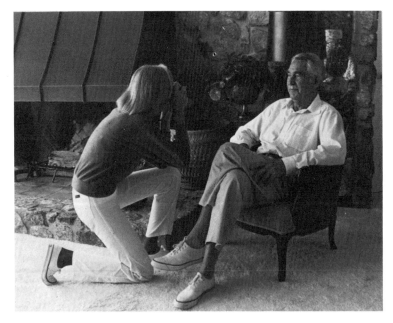

FIG. 7-1. "Too close for comfort": portraiture with a normal-focal-length lens.

distance, a long-focus zoom lens makes an excellent lens for "people-watching." At a distance you can be quite unobtrusive, and you can make a candid portrait without the subject's being aware that he or she is "on camera." You should exercise caution in the use of such photographs. Most publishers will not accept a photograph unless it is accompanied by a signed and witnessed model release from the subject.

When you are using a long-focus zoom lens for portraiture, you must pay careful attention to two factors that have been mentioned previously. The first of these is camera and/or subject motion, which can be magnified if you use a long lens, especially if the camera is hand-held. The best insurance against blurred or unclear pictures from these

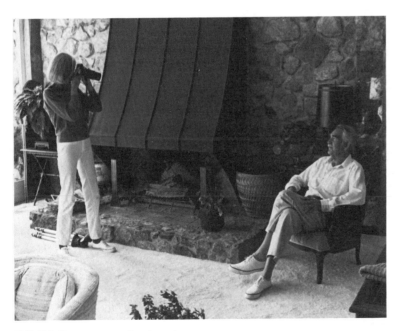

FIG. 7-2. Portraiture with a long-focus zoom lens: a more comfortable distance for both the photographer and the subject.

FIG. 7-3. The subject, at ease at a safe distance from the intrusive camera.

FIG. 7-4. Portrait of Chris, made with
a 75–205mm zoom lens set at its
75mm focal length.

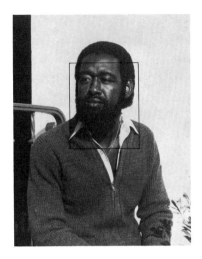

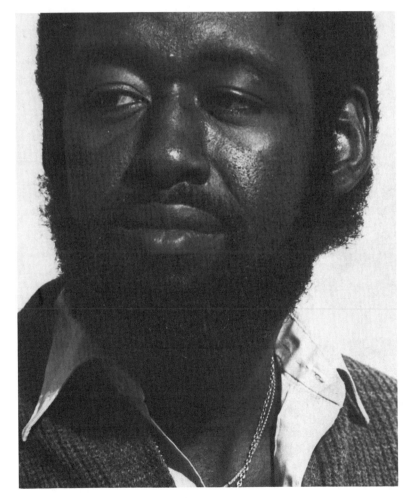

FIG. 7-5. Portrait of Chris, made with
a 75–205mm zoom lens set at its
205mm focal length.

causes is the use of a fast shutter speed such as 1/500 or 1/1000 of a second. The other factor has to do with the limited depth of field of long-focus lenses, especially if you set them at a relatively large lens aperture to permit the use of a fast shutter speed. You must focus very carefully.

Although not strictly in the realm of portraiture as we usually think of it, Figures 7-7, 7-8, and 7-9 were chosen to illustrate still another kind of situation in which zoom lenses offer decided advantages. Today there are many art museums where photography is permitted. Too often, however, important exhibits are roped off to keep viewers at a safe distance. The sculpture of the African maiden shown in these figures was photographed at such a distance, but by means of a zoom lens. Thus, you can make portrait heads that reveal many details that are too far away to be seen clearly.

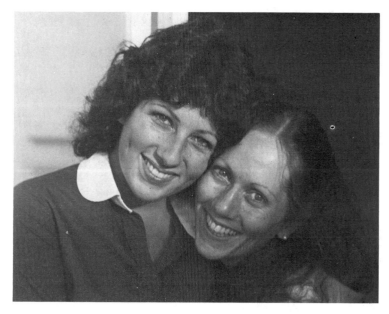

FIG. 7-6. Sisters: a double portrait.
35–85mm zoom lens set at 85 mm.
(Photo courtesy Jim Wagner.)

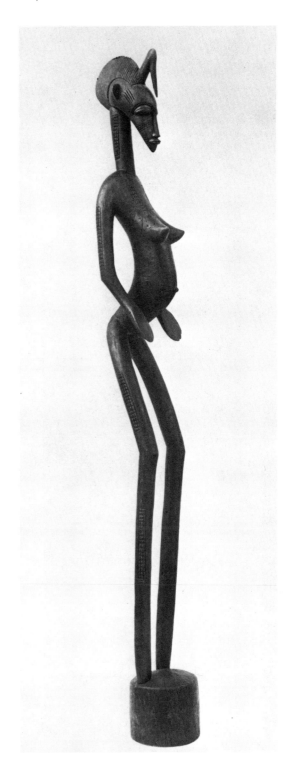

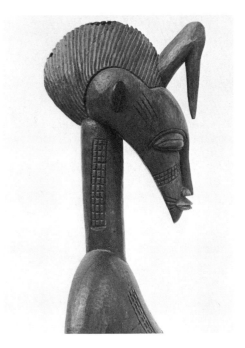

FIG. 7–8. Profile portrait.

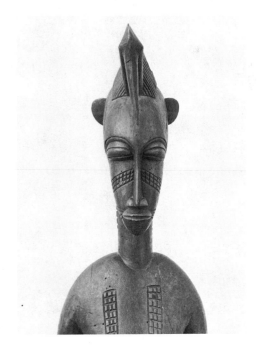

FIG. 7-7. African wood figure
sculpture (Senufo tribe, Ivory Coast).

FIG. 7-9. Full-face portrait.

NATURE

The world of nature which surrounds us is infinitely rich in photographic possibilities. It is a world of light. Visually, it is in a state of constant flux, from season to season, day to day, hour to hour, and even minute to minute. A cloud passing between the sun and the earth can completely alter the appearance of things.

The world of nature ranges from the infinitesimally small to the infinitely large. This is well expressed in lines from two poets:

To see a world in a grain of sand
And a heaven in a wild flower,
Hold infinity in the palm of your hand
And eternity in an hour.
—William Blake

The great cloud-continents of sunset seas. . . .
—Anonymous

Nature has been photographed more often and in more ways than any other subject, from electron

microscope photographs of the surfaces of crystals magnified many thousands of times to photographs of the surfaces of planets millions of miles distant. While these are ordinarily classified as scientific photographs, their subjects are nonetheless a part of the vast world of nature. While we can appreciate these remarkable feats of photography, we cannot hope to emulate them. But, in the words of another poet, we do have

. . . the world, which seems
To lie before us like a land of dreams,
So various, so beautiful, so new. . . .
—Matthew Arnold

The virtues of using a zoom lens in nature photography are essentially the ones that have been mentioned in previous chapters—in particular, the ability to alter focal length at will to photograph both the grandeurs of nature as you see them and, by means of the macro capability that many zoom lenses offer, the smaller, more intimate things. Only a very few examples are illustrated in these photographs.

FIG. 8-1. Reflections in moving water.
75–205mm zoom lens set at 205 mm.

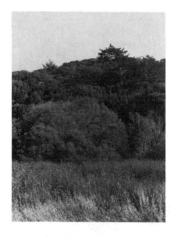

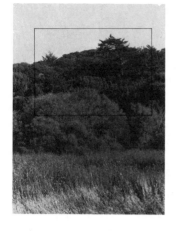

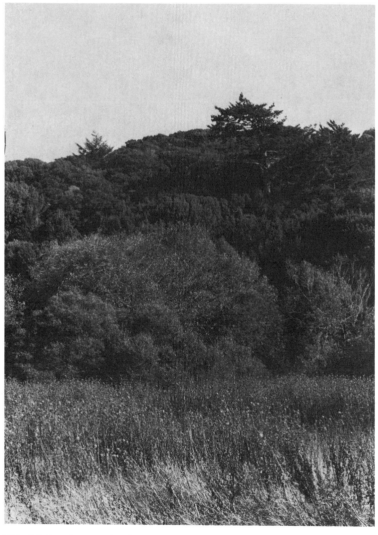

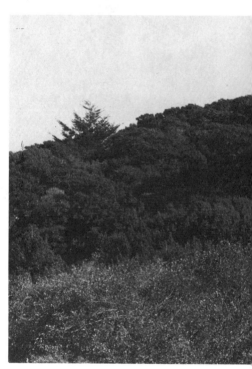

FIG. 8-3. Landscape. 35—80mm zoom
lens set at 80 mm.

FIG. 8-2. Landscape. 35—80mm zoom
lens set at 35 mm.

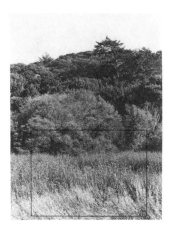

FIG. 8-4. Landscape foreground. 35–80mm zoom lens set at 80 mm.

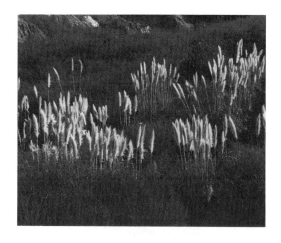

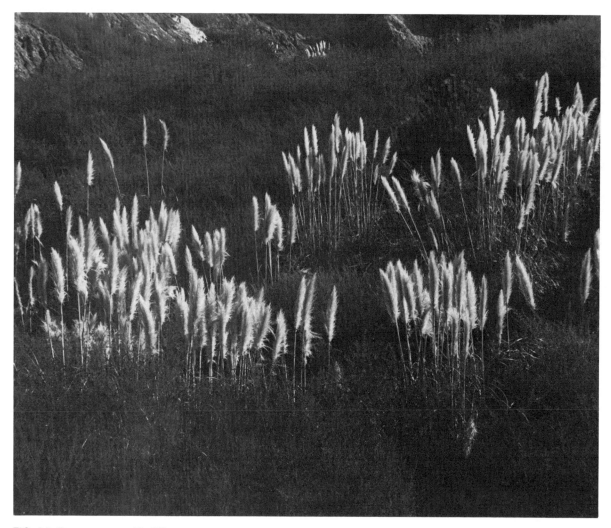

FIG. 8-5. Pampas grass. 75—205mm
zoom lens set at 75 mm.

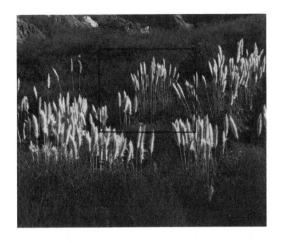

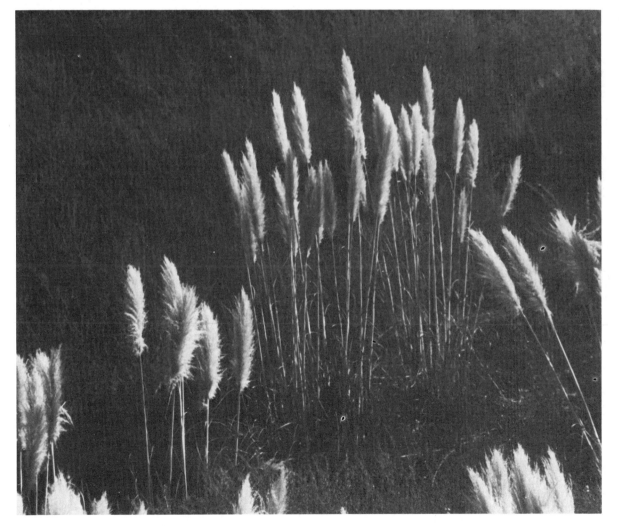

FIG. 8-6. Pampas grass. 75—205mm
zoom lens set at 205 mm.

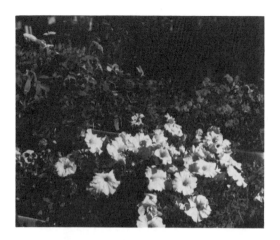

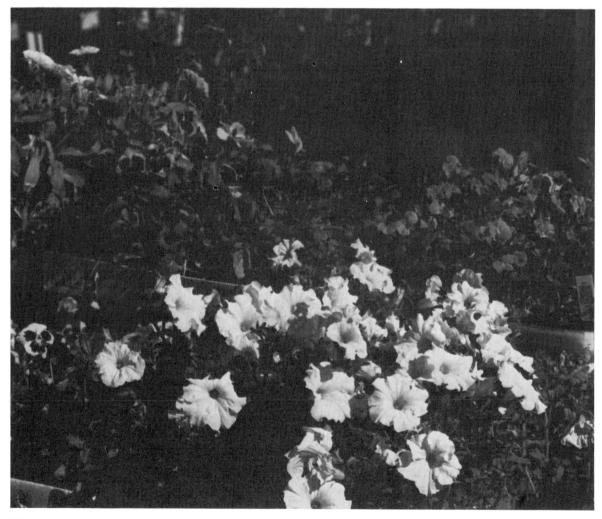

FIG. 8-7. Flower bed in a nursery.
75–205mm zoom lens set at 75 mm.

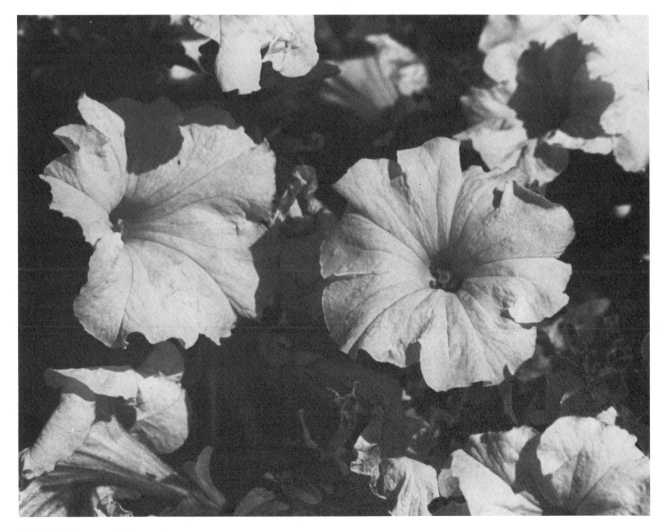

FIG. 8-8. Close-up of flowers shown
in Figure 8-7. 75–205mm zoom lens
set for macro range.

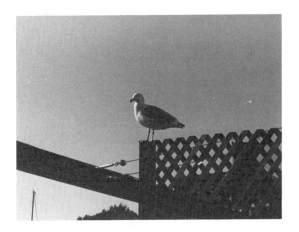

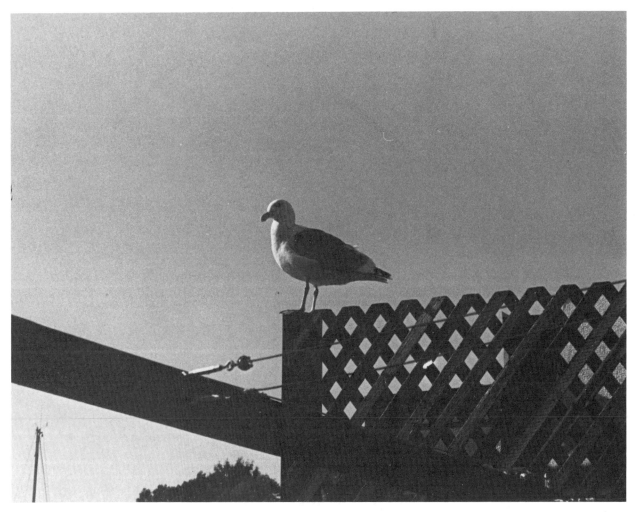

FIG. 8-9. Seagull. 75–205mm zoom
lens set at 75 mm.

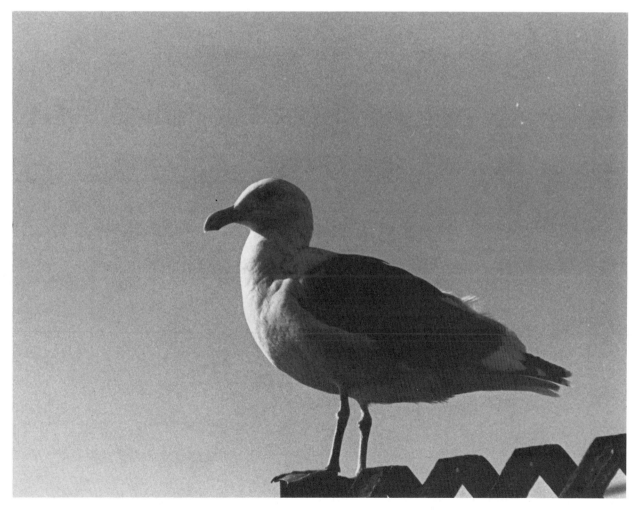

FIG. 8-10. Seagull. 75–205mm zoom
lens set at 205 mm.

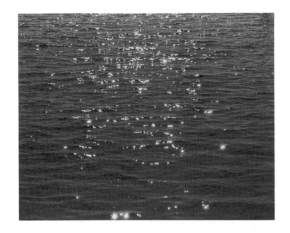

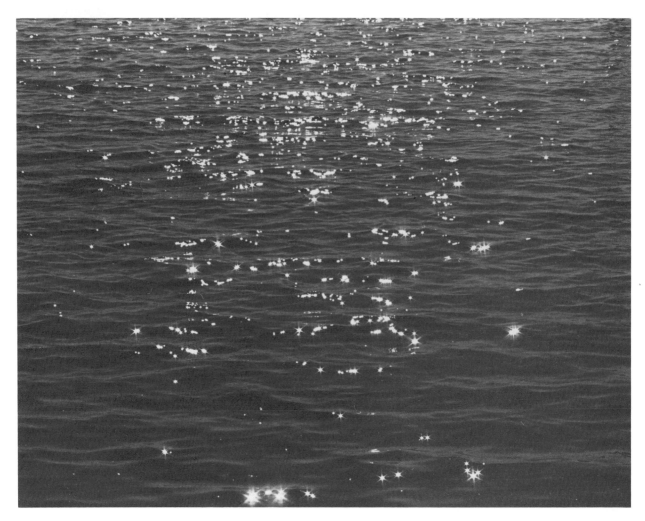

FIG. 8-11. Sun highlights on waves.
75–205mm zoom lens set at 75 mm.

FIG. 8-12. Sun highlights on waves.
75–205mm zoom lens set at 205 mm.

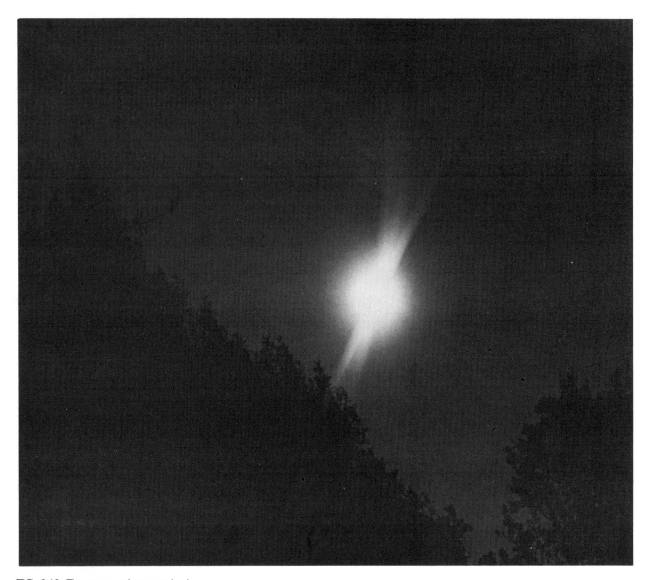

FIG. 8-13. The moon, photographed
with a 75mm zoom lens. Pointing a
lens directly at a light source can
cause flare lines.

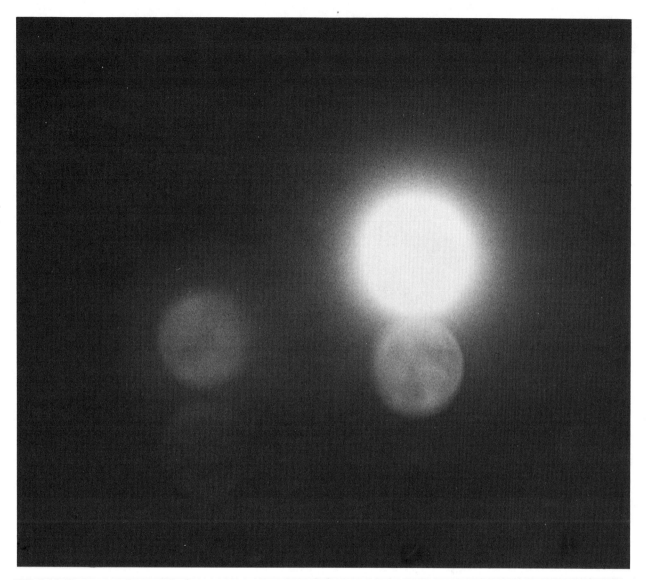

FIG. 8-14. The moon, photographed with a 205mm zoom lens. The extra moons are caused by internal reflections in the lens.

HORIZONS: LANDSCAPES, SEASCAPES, CITYSCAPES

The most important advantage that zoom lenses offer to the landscape (or seascape or cityscape) photographer is the ability to change focal length at will. In many situations, because of distance you cannot "come to the mountain," but with a long-focus zoom lens the mountain can come to you.

Consider, for example, a landscape with a picturesque barn some 300 yards distant. If you use a normal lens, the barn will be very small and the picture will include much more of the surrounding landscape than you may wish. To narrow the content of the picture to bring the barn into greater prominence, you have no alternative but to walk most of the 300 yards to get closer to the subject. But there also may be other problems. If the barn is on a hillside, approaching it more closely will alter perspective because you will have to tilt your camera upward. Further, if the ground between you

and the barn is wet or marshy, walking may be impossible. A fence in the immediate foreground may carry "No Trespassing" warnings. But if you had, say, a 75–205mm zoom lens instead of a normal lens, all of these problems would be eliminated. You could give greater prominence to the barn while at the same time including only as much of the surrounding landscape as you need to make the picture your eye had seen. (See Figures 9-3, 9-4, and 9-5.)

This ability to bring the subject to the camera is often useful also in seascape photography. You cannot approach spectacular waves crashing against an offshore rock 100 yards distant, but you can "bring them inshore" to whatever distance you choose by means of a long-focus zoom lens.

In cityscape photography, the reverse may often be true. The confines of streets and buildings may be too restrictive if you are using a normal lens with its angle of view of approximately 46°. If instead of using a normal 50mm lens you use a wide-angle zoom lens with a focal length of 28–50mm, you can increase the angle of view by nearly 30 degrees, selecting the focal length and angle of view that will provide you with the picture content you seek.

Examples of zoom lens photographs of these three types of subject matter are shown in Figures 9-11 to 9-17.

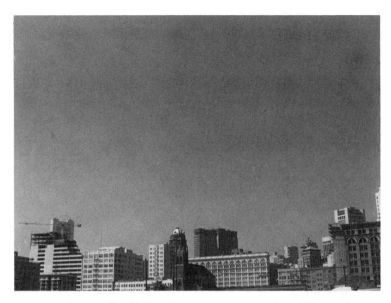

FIG. 9-1. Cityscape photographed
with a normal lens.

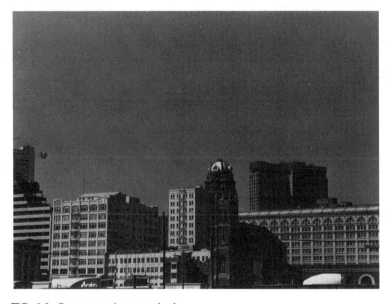

FIG. 9-2. Cityscape photographed
with a long-range zoom lens.

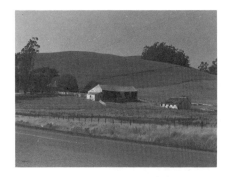

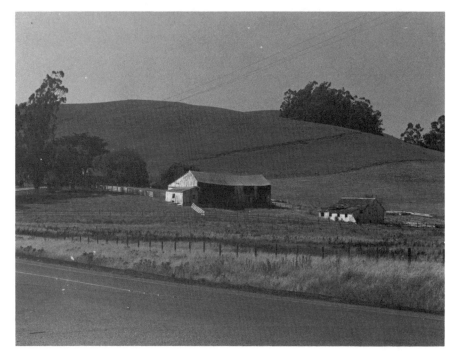

FIG. 9-3, 9-4, 9-5. Closing the distance between camera and subject by zooming to progressively longer focal lengths.

FIG. 9-4. Focal length: 205 mm.

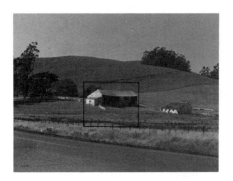

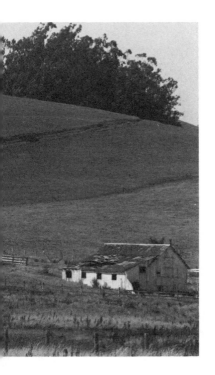

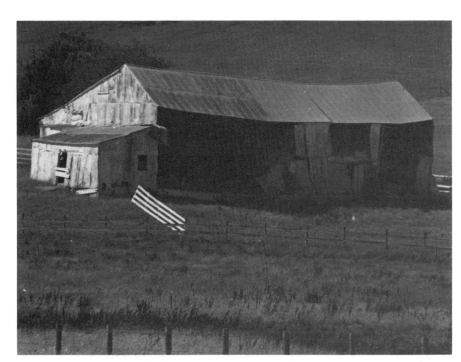

FIG. 9-5. Focal length: 410 mm.

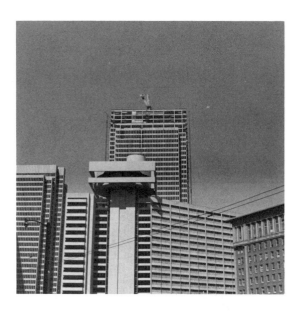

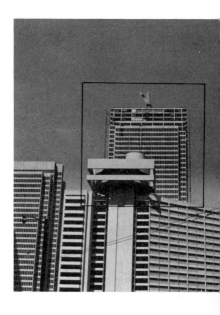

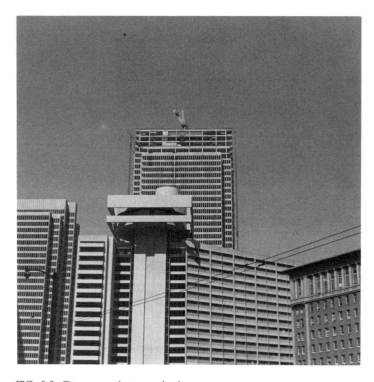

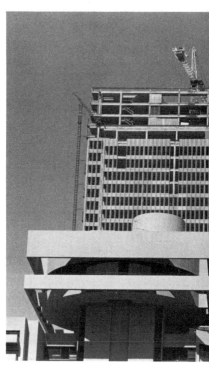

FIG. 9-6. Cityscape photographed
with a normal lens.

FIG. 9-7. Cityscape photographed
with a medium-range zoom lens.

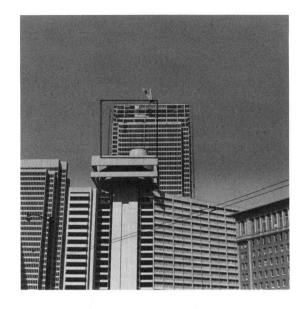

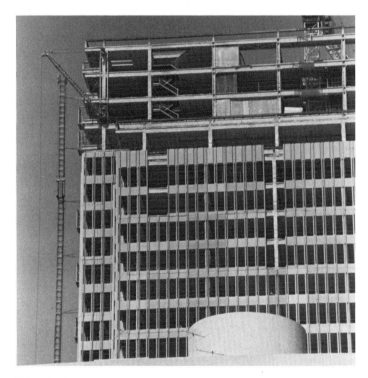

FIG. 9-8. Cityscape photographed
with a long-range zoom lens.

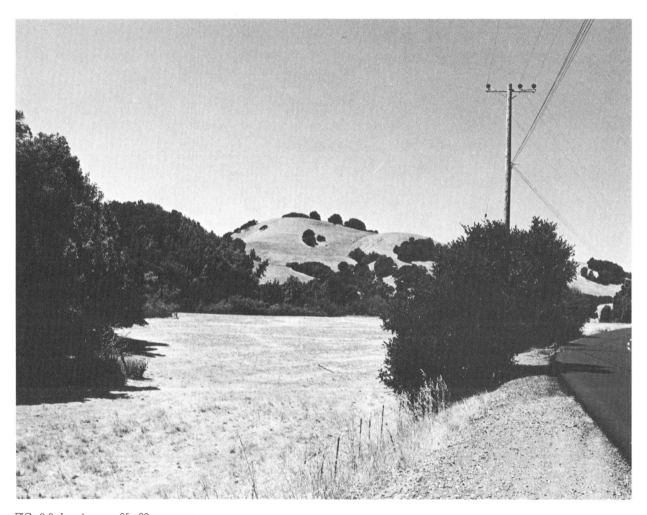

FIG. 9-9. Landscape. 35–80mm zoom
lens set at 50 mm.

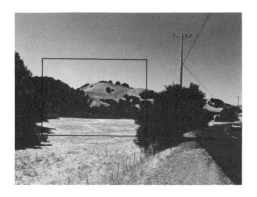

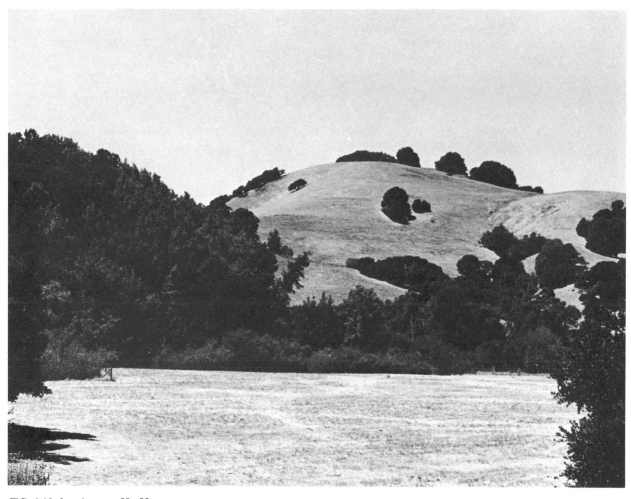

FIG. 9-10. Landscape. 35–80mm
zoom lens set at 80 mm.

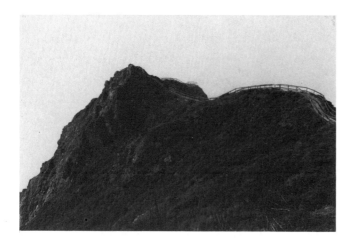

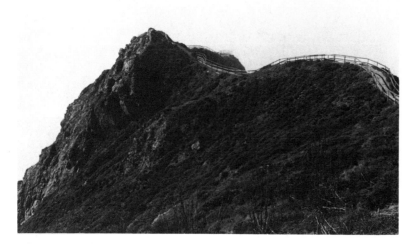

FIG. 9-11. Promontory with fenced trail. 50mm lens.

FIG. 9-12. Promontory and fenced trail. 75–205mm zoom lens set at 205 mm.

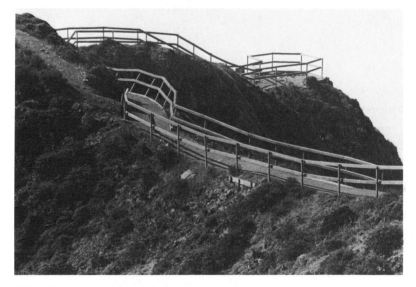

FIG. 9-13. Promontory and fenced trail. 75–205mm zoom lens with 2X tele-extender for a focal length of 410 mm.

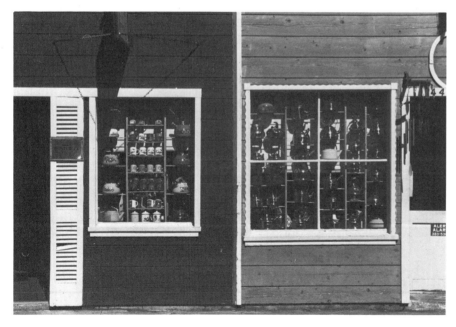

FIG. 9-14. In photographing village
scenes where streets are often
narrow, you can include either more
or less in the picture simply by
varying the focal length from wide to
narrow, without changing the
camera-to-subject distance.

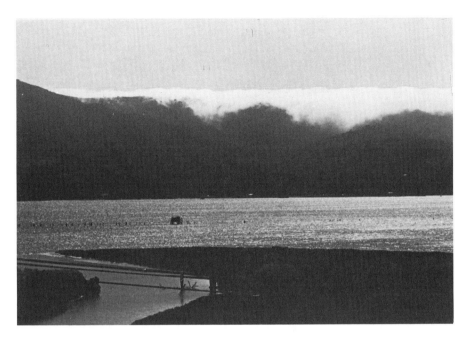

FIG. 9-15. Restricted angle of view
when using an 80mm focal length.

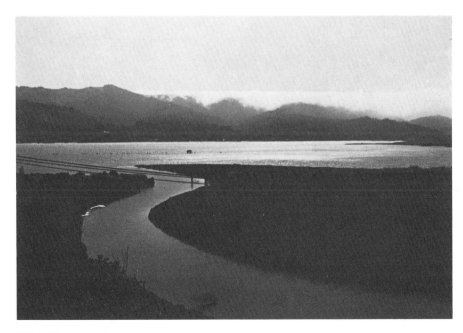

FIG. 9-16. Greatly broadened angle of
view when using a 35mm focal length
lens.

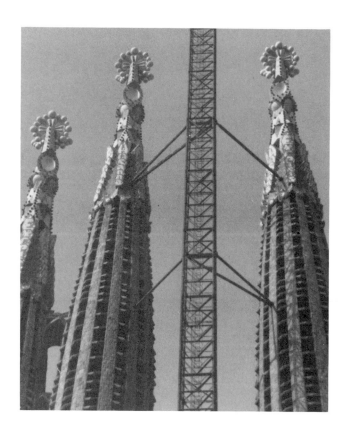

ARCHITECTURE

With their extensive command over both focal length and angle of view, zoom lenses are very useful tools for the architect and the student of architecture. A macro capability extends their utility still further.

Architectural works come in all sizes, from garden gazebos to skyscrapers. In addition, works of architecture have both interiors and exteriors having more than one façade. Although they enclose a space, they are also enclosed within a space. When you photograph architecture, you are thus presented with a number of problems.

One problem that often occurs in architectural photography derives from the fact that many structures are tall and more often than not have to be photographed from ground level. This means you will have to tilt the camera upward to include the entire façade, which in turn alters perspective. Ver-

tical parallel lines appear to converge and the building might look as if it tilts backward. This distortion of perspective can be eliminated if you greatly increase the camera-to-subject distance so that you can include the entire building façade in a photograph taken with the camera in a level position. This increase in distance, however, may oblige you to include far more in the picture than you wish. There may be much too much foreground, and the image of the building might be very small. On the other hand, spatial restrictions may make it impossible for you to back off to a distance great enough to make a photograph that is rectilinear and true.

Two possibilities for solving or at least minimizing these problems are offered by zoom lenses.

1. If you can back far enough away from the subject to produce a photograph in correct perspective on a reduced scale, you can then use a zoom lens to close the apparent camera-to-subject distance and obtain a much larger image.

2. If you are confined by spatial restrictions, you can use a wide-angle zoom lens to broaden the angle of view sufficiently to include the entire building without tilting your camera.

In either situation, the fluid control over focal length and angle of view that zoom lenses provide makes it possible to obtain the picture you seek.

A somewhat different set of problems exists in photographing architectural interiors. Some interiors are vast, such as those of cathedrals, airline terminals, opera houses, and other spaces designed to accommodate large numbers of people, but

many—private residences, apartments, offices—are much more modest in scale. Interiors of the latter kind seldom involve a height problem because the distance between floor and ceiling is relatively short, but they can involve a width problem. Because interiors are bounded by four walls, spatial constraints on your freedom in establishing a suitable camera-to-subject distance can be acute. Here again, a wide-angle zoom lens can be very helpful.

A long-focus zoom lens offers other advantages when you are photographing architecture. Buildings often have architectural or ornamental details that are simply too high to record clearly for later study if you use a normal lens. Take, for example, the crosses or cupolas that are found on New England churches and other buildings. Although an upward tilt of the camera will introduce distortion, you can nonetheless selectively record such details by means of a long-focus zoom lens. In this case, the zoom lens in effect brings the subject down to you. (See Figures 10-1 through 10-8.)

Although not considered to be architecture, there are endless numbers of industrial subjects that are rich in pictorial possibilities. All of the advantages that zoom lenses bring to architectural photography also apply to industrial subjects, with great effect. (See Figures 10-9 and 10-10.)

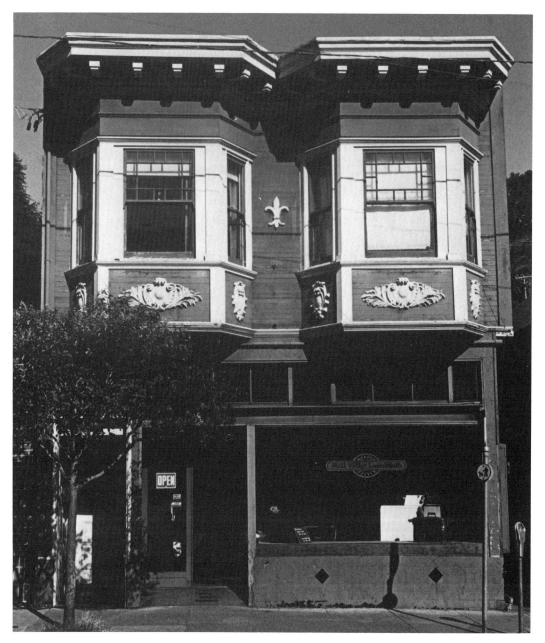

FIG. 10-1, 10-2, 10-3. Photographic
studies of a Victorian-style storefront.
(ca. 1900)

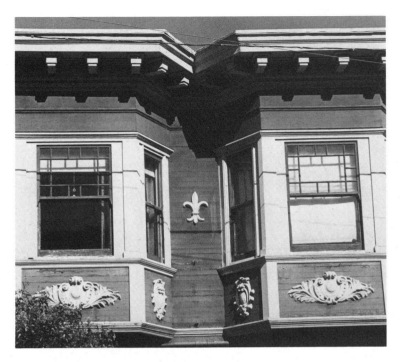

FIG. 10-2. Window and molding
details.

FIG. 10-3. Surface ornamentation.

FIG. 10-4. The photographer (center foreground) attempts to get pictures of architectural detail using a camera equipped with a normal lens.

FIG. 10-5. The results. In addition to distortion created by the steep camera angle, much of the detail is missing.

FIG. 10-6. By moving to the opposite side of the street and using a long-range zoom lens, the desired details are recorded, and with greatly reduced distortion.

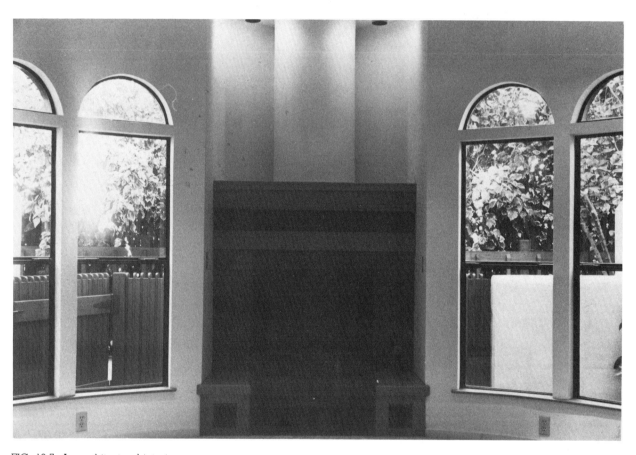

FIG. 10-7. An architectural interior
photographed at the maximum
camera-to-subject distance with a
normal lens.

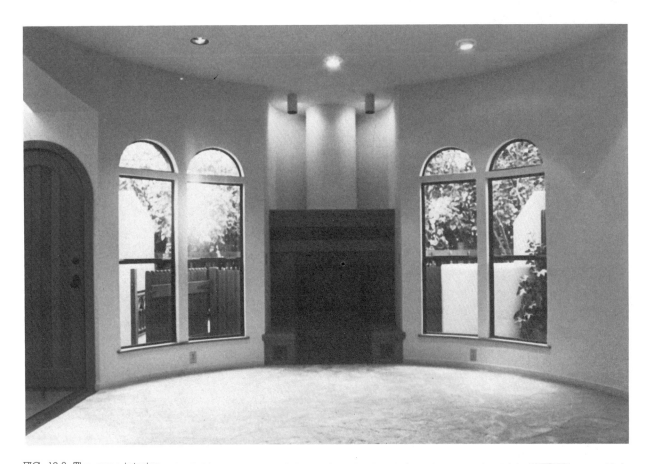

FIG. 10-8. The same interior
photographed with a 28mm zoom
lens. Nearly twice as much can now
be included.

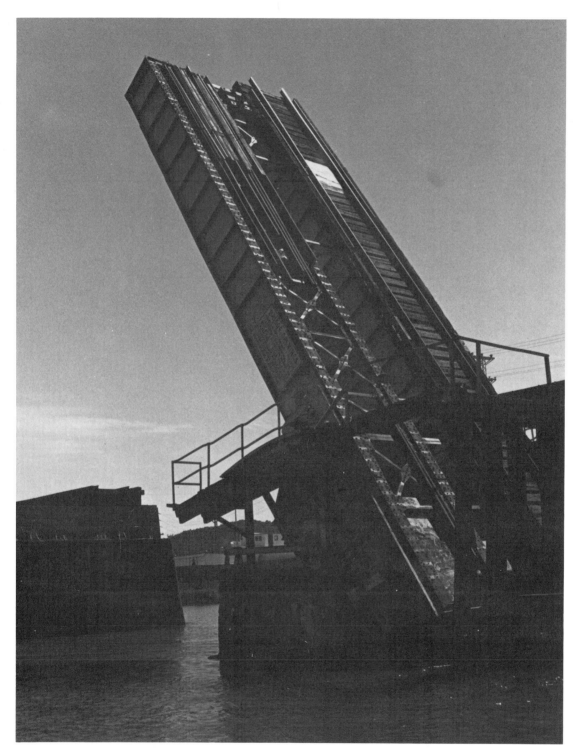

FIG. 10-9. Canal bridge
photographed with a normal lens.
The water effectively prevents a
closer approach.

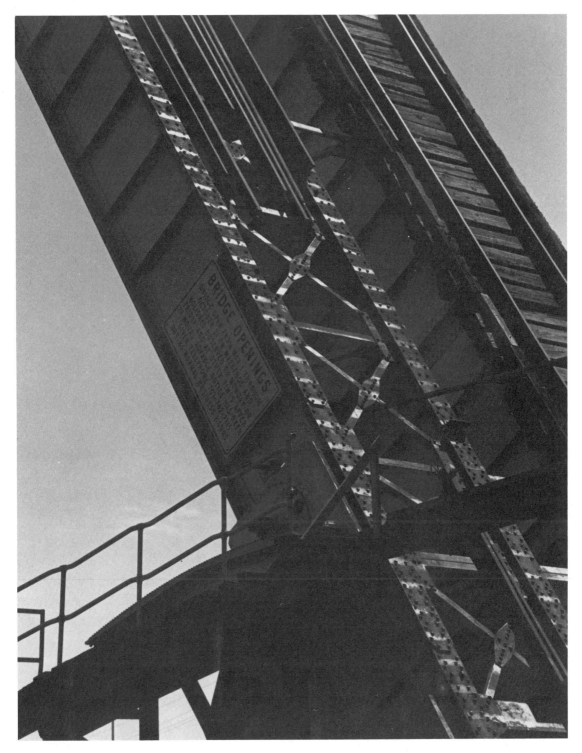

FIG. 10-10. By using a zoom lens, the
bridge can be brought to the camera.

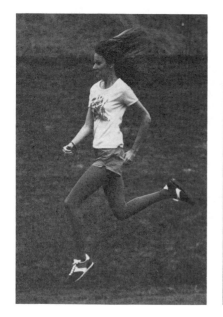 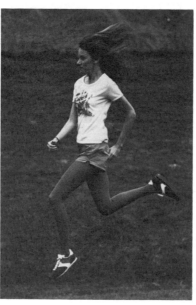 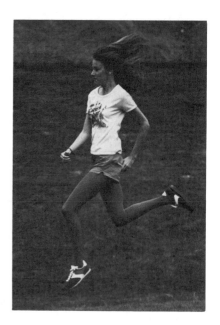

ACTION: THE WORLD IN MOTION

By definition, "action" in reference to visual events means subjects in motion. Our daily lives are surrounded by moving objects—pedestrians walking, children playing, vehicles moving on streets and highways, airplanes passing overhead. In the world of entertainment, we have the movements of actors or dancers on the stage or the rapid action of sports events. In the world of nature, we find the slow drifting of clouds, tree branches whipped in a strong wind, or the constant movement of bodies of water, from ripples on a pond to crashing breakers. And we ourselves are part of the continuous world of movement.

To make successful photographs of motion and action, you must observe and understand certain principles. Your camera is equipped with a shutter which can be set for shorter or longer exposure intervals, commonly referred to as slower or faster shutter speeds. It would seem that to "freeze" a mo-

ment of action, you would obviously choose to use the fastest possible shutter speed; but this is not necessarily the case. How quickly an action is *actually* taking place and how quickly it *appears* to be taking place are two different things.

Consider, for example, watching a freight train through the viewfinder of your camera at a distance of one mile. Although the freight train might be traveling at 70 miles an hour, it appears to move very slowly across your field of vision. Even the use of a relatively slow shutter speed will "stop the action." However, when you see the train at a distance of 100 feet, it races past your field of vision far too fast to stop the action, even at the very fastest shutter speed.

In another example, a jet airplane at an altitude of several thousand feet appears to float across the sky, even though its actual speed might be in excess of 600 miles per hour. The first principle, therefore, is that speed of movement and camera-to-subject distance are interrelated.

Using a fixed-focal-length lens, you can approach your subject closely; but the closer you come, the faster your shutter speed will have to be to stop the action. But with zoom lenses, you do not have to approach your subject closely, which is to say at a shorter camera-to-subject distance. Instead, your zoom lens will in effect bring the subject to you. But the result will be the same. If you use a long focal length, the size of the image will be magnified, *but the degree of motion will also be magnified.* A zoom lens thus creates the illusion that the camera-to-subject distance has been shortened, although no such change actually takes place. Therefore, in using a zoom lens to photograph action, you cannot move from a short focal length to a long focal length with

the expectation that the action-stopping shutter speed you have selected will produce identical results. *As you move to a longer focal length, the shutter speed will have to be faster.*

To illustrate how to photograph a moving subject with a zoom lens at a fixed camera-to-subject distance but at various focal-length settings, our photographer used a single subject: a runner. He used different shutter speeds in order to determine which speed would stop the action for each of the three focal lengths, and which would not. The three focal lengths were 75 mm, 135 mm, and 205 mm. A sequence of four pictures was made for each focal length. The captions for the twelve figures (Figures 11-1 to 11-12) show which focal lengths and shutter speeds the photographer used to determine what shutter speed stopped the action.

In these illustrations, the subject is moving directly across the field of vision and the camera is in a stationary position. If the subject were moving diagonally toward or away from the camera, there would be less evidence of transverse motion. Hence, a slower shutter speed would suffice to stop the action. You could use a still slower shutter speed if the subject were moving directly toward or away from the camera.

When photographing subjects moving at much higher speeds than a runner does, photographers usually depend on "panning." Instead of holding the camera stationary, the photographer constantly moves it synchronously with the movement of the subject. (See Figure 11-13.) Because the camera is following the subject as it moves, the photographer can stop action even though the camera-to-subject distance is relatively short and the speed of the subject very fast.

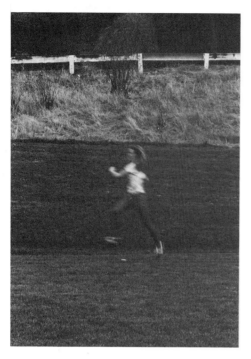

FIG. 11-1. Focal length: 75 mm.
Shutter speed: 1/30 sec.

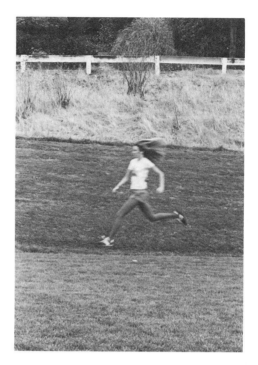

FIG. 11-2. Focal length: 75 mm.
Shutter speed: 1/60 sec.

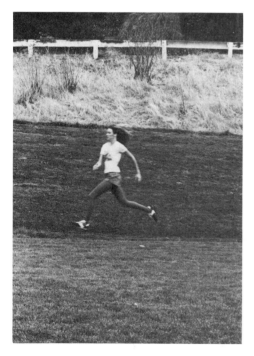

FIG. 11-3. Focal length: 75 mm.
Shutter speed: 1/125 sec.

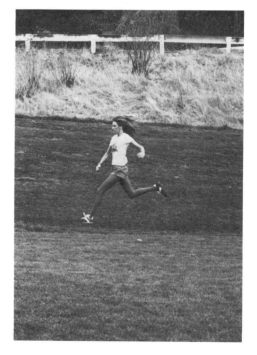

FIG. 11-4. Focal length: 75 mm.
Shutter speed: 1/250 sec.

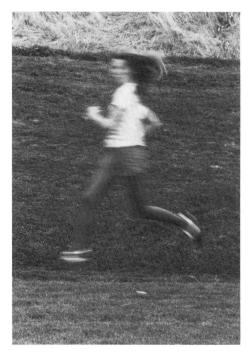

FIG. 11-5. Focal length: 135 mm.
Shutter speed: 1/60 sec.

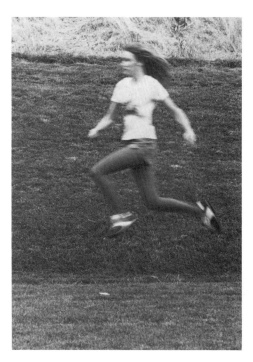

FIG. 11-6. Focal length: 135 mm.
Shutter speed: 1/125 sec.

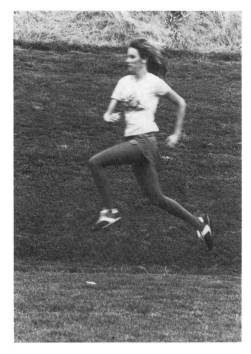

FIG. 11-7. Focal length: 135 mm.
Shutter speed: 1/250 sec.

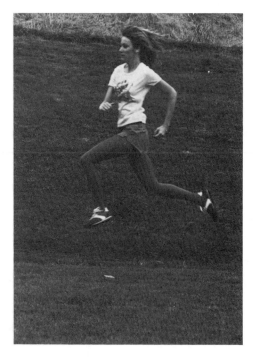

FIG. 11-8. Focal length: 135 mm.
Shutter speed: 1/500 sec.

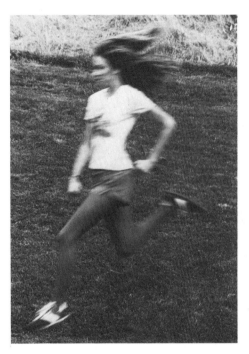

FIG. 11-9. Focal length: 205 mm.
Shutter speed: 1/125 sec.

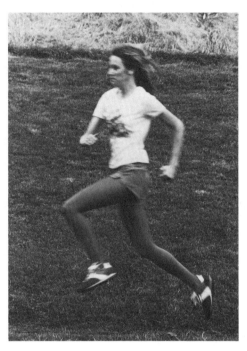

FIG. 11-10. Focal length: 205 mm.
Shutter speed: 1/250 sec.

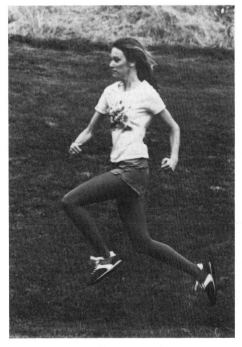

FIG. 11-11. Focal length: 205 mm.
Shutter speed: 1/500 sec.

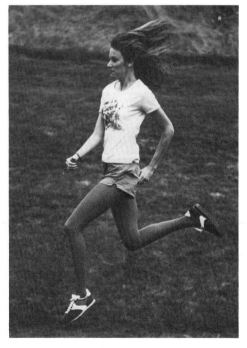

FIG. 11-12. Focal length: 205 mm.
Shutter speed: 1/1000 sec.

Unless the camera is on a tripod, hand motion in panning may introduce another factor which can only be overcome by the use of a very fast shutter speed. The basic rules in photographing moving subjects, therefore, are:

1. The faster the action is, the faster the shutter speed must be.

2. The shorter the camera-to-subject distance is, the faster the shutter speed must be. Remember at all times that when you use a zoom lens, you can create the exact equivalent of either a shorter or longer camera-to-subject distance.

3. The longer the focal length you use, the faster the shutter speed must be.

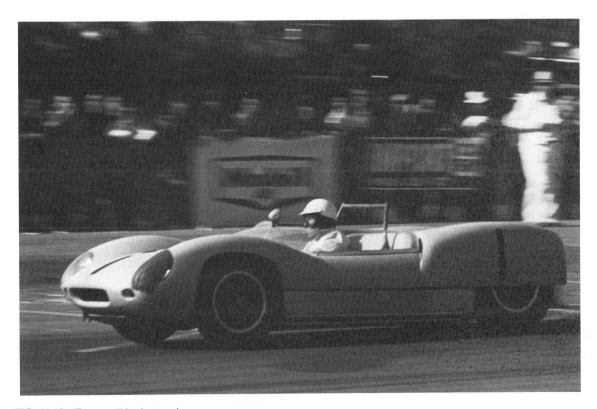

FIG. 11-13. "Freezing" high-speed action by panning. The evidence of speed is shown in the blurred background.

EXTENDING THE ZOOM RANGE WITH ACCESSORIES

Many lens accessories that are commonly used with conventional fixed-focal-length lenses are also available for use with zoom lenses. These include correction filters, contrast filters, polarizing filters, and special-effects devices. The list also includes protection filters, which are neutral in their effect but can prevent accidental damage from scratching of the front element of a costly zoom lens. As such, they are a useful and inexpensive form of insurance.

One of the most important accessories for a long-focus zoom lens is a sturdy tripod. A tripod eliminates the hazard of camera movement during exposure. When working with a tripod, you should also use a cable release. To test a tripod, set it for its maximum height. A light-weight, supercompact, flimsy tripod cannot do the job of supporting a relatively heavy zoom lens with assured stability.

The accessory that is of principal importance to

zoom lens users is an optical device that can increase the focal length of the lens when added to the camera-lens system. Such devices, variously known as tele-extenders, matched multipliers, or matchmates, depending on the manufacturer, are not simple over-the-lens accessories. They are complex, multi-element optical devices designed specifically to match and to be paired with particular zoom lenses. They thus become a perfectly coordinated addition to the lens.

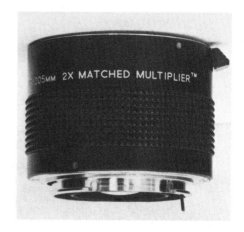

FIG. 12-1. A 2X tele-extender used to double focal length.

To simplify nomenclature, we will refer to these accessories as tele-extenders to reflect the function they essentially perform. Apart from their optical capabilities, tele-extenders offer a zoom lens owner another advantage—in the pocketbook. If, for example, you have a 75–205mm zoom lens, you can increase its focal-length range to 150–410mm by means of a tele-extender. Purchased separately, a 410mm zoom lens is quite expensive. A tele-extender that will give you the power and the reach of a 410mm lens costs less than $100 in today's marketplace.

There are, however, some precautions that you must take into account when you introduce a tele-extender into the optical system. Because it increases the lens-to-film distance, a 2X tele-extender, for example, will decrease the light-gathering power of the lens by a factor (in terms of exposure) of four. The marked aperture settings on the lens barrel are not accurate when you use a tele-extender. For example, if a lens has marked aperture settings of f/3.5, f/4.5, f/5.6, f/8, f/11, f/16, and f/22, the *effective* apertures when you use a tele-extender will become f/7, f/9, f/11, f/16, f/22, f/32, and f/44. This is a difference of two f-stops, which will require an increase of four times in exposure.

If you use a camera with a built-in or automatic metering system, the meter will indicate the needed increase in exposure. If you use an off-the-camera meter, you will have to take this four-times increase over the marked f-stop settings into account. With a tele-extender, f/8 is no longer f/8. It has become f/16. Some tele-extenders are equipped with a separate scale that shows what the effective f-stop actually is, but others are not. The scale shows you that f/8 is now f/16 in terms of exposure requirements.

One way to compensate for the reduction in f-stop value with an off-the-camera meter is to change its ASA setting. If, for example, you are using a film having an ASA speed rating of 400, you can change your meter to a setting of ASA 100.

Other important factors to bear in mind when you are using a tele-extender to extend the focal length have been mentioned previously in other contexts. At a focal-length setting of, say, 410 mm, depth of field is extremely shallow. You must focus very carefully. Also, the increased magnification of the image will not allow for any camera movement if you are

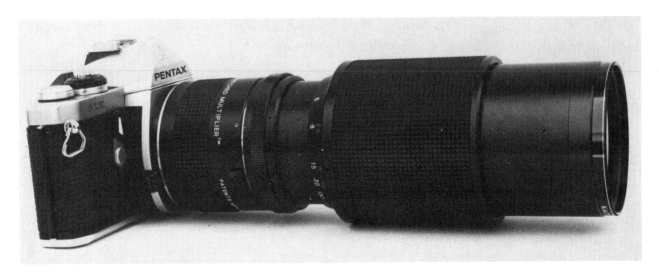

FIG. 12-2. Camera and lens with 2X tele-extender in place.

to obtain a sharp picture. A tripod becomes essential.

You should also note that the use of a tele-extender that increases the magnification of the image also increases the close-up capability of a macro-zoom lens. You can photograph areas as small as 1⅓ × 2 inches or even smaller, depending upon the lens.

It should be added that not all tele-extenders work at a fixed increase in focal length of 2X. 1½X and 3X tele-extenders are offered by some lens manufacturers.

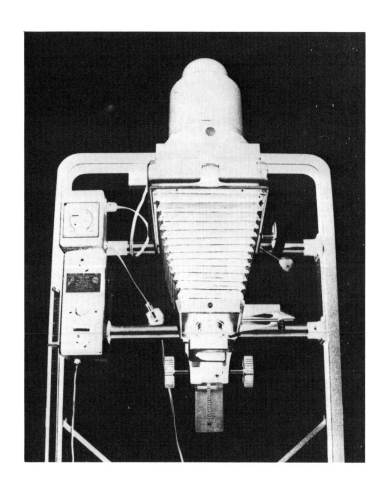

EXTENDING THE ZOOM RANGE IN THE DARKROOM

Before the invention of zoom lenses, a photographer could simulate their effect by enlarging a negative. By cropping and increasing the lens-to-printing-paper distance with the enlarger, he or she could print, say, only the central portion of a negative. Though the enlarger thus served as a kind of zoom lens, this method had its limitations. You can enlarge a negative only so much before the image begins to break down and become blurry because of the grain structure of the film. The smaller the portion of the negative used and the greater the degree of enlargement, the more noticeable the loss in image sharpness and quality.

A zoom lens allows you to crop with your camera lens. You always have a full negative, instead of only a small portion, to print from.

The films available today are sufficiently fine-grained to permit a considerable degree of enlargement before loss of sharpness becomes noticeable.

With a zoom lens, you have at your command the best of two worlds. You can crop a scene by extending the focal length of your zoom lens, and then crop it still further with your enlarger. By enlarging only a portion of a negative, you can in effect produce a print virtually equivalent to the one you would have obtained if you had used a zoom lens of a much longer focal length. For example, a print made from a negative taken with a 150mm zoom lens can be equivalent to a print made from a negative taken with a 300mm zoom lens, while still maintaining a satisfactory level of sharpness.

FIG. 13-1. Extending: photograph of lamppost taken with 75–205mm zoom lens set at 75 mm.

Cropping with an enlarger can also increase the close-focus capability of macro zoom lenses. For example, if you use a macro zoom lens to photograph an approximately 2 × 3 subject at a maximum close-focusing distance of 5 inches, an enlargement from a portion of the negative will be equal to a photograph made at a much closer distance.

The ability to crop a scene first with a zoom lens and then still further by means of an enlarger greatly extends the already considerable capabilities of zoom lenses. (See Figures 13-1 through 13-3.)

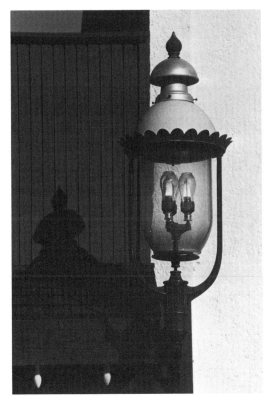 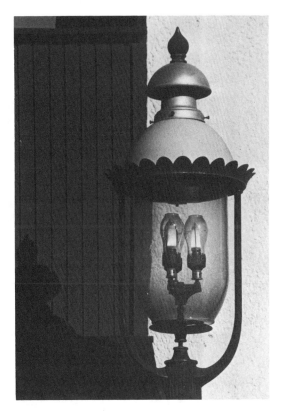

FIG. 13-2. Extending: photograph of lamppost taken with 75–205mm zoom lens set at 205 mm.

FIG. 13-3. Extending by means of an enlarger. This print was made from a section of the preceding illustration. The result is equivalent to what you would obtain if you used a zoom lens of approximately 300 mm.

CHOOSING A ZOOM LENS

Most camera users today own one of the many high-quality 35mm SLR cameras which have come into widespread use throughout the world. Professional photographers rely on them extensively. Such cameras are usually equipped with a normal lens having a focal length of 50mm or 55mm. Much fine photography can be done with this camera-and-lens combination. But a time may come when you are browsing in a camera shop, talking with other camera owners, or reading the alluring advertisements in magazines and the "zoom bug" begins to bite. Here is a type of lens that can do everything the normal lens can, but in addition it can do so much more! You can do wide-angle photography, telephotography, and macrophotography with only a single lens.

A camera owner's first experience with actually looking through a zoom lens and realizing all that it can do often results in instant infatuation, love at

first sight. Caught by the magic of a zoom lens and dreaming of the marvelous photographs to be made with it, the photographer feels a strong temptation to buy. But which zoom lens?

At this point, caution must enter. There are so many zoom lenses to choose from. As a prospective purchaser, pause and ask yourself a number of questions. Take the time to explore the many possibilities and alternatives open to you. The most important questions, at the very start, are:

What do I intend to use a zoom lens for?
What kinds of photographs do I want to make?
What subjects do I prefer?

The answers to these questions will be a start toward narrowing the selection process. Consider some typical examples:

RZ is an ardent backpacker. In backpacking, the size and weight of every item is important. To photograph mountain scenery as well as wildflowers, he needs a wide-angle to semi-telephoto zoom lens with macro capability.

MT's hobby is bird-watching. She will need a zoom lens with a long focal length.

DG is devoted to stage photography. To work within the limits of stage lighting, he will need a zoom lens with the largest possible maximum aperture.

JK is an architect. The photographs she needs to make of architectural interiors will require a wide-angle zoom lens.

Such cases are typical of both hobbyists and professionals, but most camera owners whose interests are general will find their picture-making needs best satisfied with a middle-range zoom lens having both a wide-angle and a telephoto capability, or, as a complement to their normal lens, a zoom with a range beginning around 70 mm and extending to 150 mm or 200 mm. In sum, there is no "best" zoom lens. The best zoom lens is the one that best suits your needs and your pocketbook. In a market that has become intensely competitive, however, price is not necessarily an index of quality. In choosing a zoom lens, seek out a reliable camera shop with a knowledgeable staff.

At the time you decide to purchase a zoom lens, arrange to purchase it conditionally on a ten days' trial basis so you can test its performance. We recommend the following procedures to test a zoom lens.

1. First of all, the performance of zoom lenses, like that of other lenses, can be affected by certain interference factors that decrease the sharpness of the image. The principal ones that you must avoid in testing any lens are subject motion and body or hand motion. A body is a "bipod" and often, at best, a rather unsteady one.

2. You must mount your camera and zoom lens on a sturdy tripod to eliminate any possibility of movement. Use a cable release.

3. If the camera and lens are sturdily supported, vibration factors such as the abrupt snap of the camera mirror and the mechanical movement of the shutter will be eliminated.

4. The subject you choose should be a completely stationary one.

5. Select an essentially two-dimensional subject, such as the flat, rectilinear façade of a building with ample surface details in low relief.

6. You should position the camera so that the film plane and the subject plane are parallel. If you photograph the subject at an angle instead of straight on, you may notice some falloff in image sharpness because of depth-of-field factors, which will interfere with a true assessment of lens sharpness.

7. Photograph the subject at various camera-to-subject distances, from far away to nearby. Include extreme close-ups of small details if your zoom lens has a macro capability.

8. Photograph the subject at three or four different focal lengths, covering the range from minimum to maximum.

9. Choose a relatively slow, fine-grained film that will allow you to test the lens's performance at all apertures from the largest to the smallest, varying the shutter speed in accordance with the aperture.

10. If you are testing a long-range zoom lens (for example, 300 mm) or a zoom with a tele-extender that will extend the focal length even more, be sure to choose for your testing a perfectly clear day, when distant objects are clearly and sharply defined. Even a slight degree of atmospheric haze will cause some softening of image sharpness. You must not construe this as the fault of the lens.

11. Keep careful notes of each picture you make, listing the camera-to-subject distance, the focal length, the aperture, and the shutter speed. Such a series of photographs, if carefully executed, will provide you with an accurate profile of the optical performance of the lens.

One further point is worth special mention. If your preference is for a short-focal-length zoom in the wide-angle to normal range, be sure to check for "barrel distortion"—a not uncommon aberration in wide-angle lenses. To do this, select a subject that has both horizontal and vertical lines. Carefully align your camera so that it is as near to a perfectly perpendicular position as possible, without any angle or tilt, so that the horizontal lines will be horizontal and the vertical lines vertical. If your lens does have barrel distortion, lines near the edge of the frame will appear to be slightly curved. Although this would be unnoticeable and of little consequence for many subjects, the distortion would be evident in photographs of architectural or other rectilinear subjects.

The main advantages and disadvantages to consider in selecting a zoom lens can be summed up as follows.

Cost. Zoom lenses may cost considerably more than fixed-focal-length lenses in the medium wide-angle to the moderate telephoto range. However, a single zoom lens can cover this entire range. For example, separate lenses having focal lengths of 35 mm, 50 mm or 55 mm, and 85 mm would cost much more than a zoom lens covering this range and also all focal lengths between. Thus, when you purchase a zoom lens, you are in effect purchasing a whole family of lenses.

The cost advantages of zoom lenses in the long telephoto range are also quite evident. The rule of thumb for fixed-focal-length telephoto lenses is simply that the longer the focal length is, the higher the cost will be. To reach into the 200mm, 300mm, or

400mm range can be very costly indeed. Relatively speaking, a zoom lens having a maximum focal length of 205 mm is not a forbiddingly costly lens. By adding a 2X accessory multiplier, which costs considerably less than the lens itself, you can increase the maximum focal length of the lens to 410 mm at a much lower cost than if you purchased a separate lens in the 400mm range.

Size and Weight. Zoom lenses are larger and heavier than normal lenses, but a zoom lens covering a focal-length range of 35mm–85mm is far less bulky and heavy than three separate lenses would be. Over 1¼ pounds of separate lenses could be matched by a single zoom lens weighing only ¾ of a pound.

Convenience. Without question, zoom lenses are far more convenient to use than separate lenses covering an equivalent focal-length range. All focal lengths of a zoom lens, from minimum to maximum, can be commanded instantly. You do not need to change from one lens to another lens to still another, nor do you need to carry two or more cameras.

Maximum Aperture. In this respect, zoom lenses in general are thus far at a disadvantage. With fixed-focal-length lenses in the wide-angle to short telephoto range, you can obtain apertures of f/2 or even larger. Normal lenses in the 50mm–55mm range having maximum apertures of from f/1.8 to f/1.2 are quite common. High-performance zoom lenses having equivalent maximum apertures have not yet appeared.

Optical Performance. In the course of preparing this book, zoom lenses of several different focal-length ranges from different well-known lens manufacturers were used. None could be faulted on overall optical performance. Because zoom lenses of virtually identical specifications are offered by several different manufacturers at different prices, you should seek the advice of a reputable camera dealer in making a choice.

SUMMARY

It is to be hoped that with this book and the illustrations contained in it, the door to the world of zoom lens photography is now wide open. You have been introduced to many of the very considerable advantages that zoom lenses offer and you have been cautioned about certain limitations. If you use your lens properly, the results can be most rewarding.

A zoom lens is truly many lenses in one. A camera with a zoom lens makes a wonderful traveler's camera. Wide-angle views of scenery, telephoto pictures of distant subjects, and close-up photographs of small objects such as wildflowers can all be made with a single lens.

A zoom lens is an ultra-precise optical instrument consisting of a whole family of different lens elements, each of which contributes to the performance of the lens. In addition, a zoom lens is a masterpiece of highly sophisticated manufacturing techniques. Both optically and mechanically, every step in the manufacture of a zoom lens must be absolutely pre-

cise. Although quite rugged, zoom lenses must be treated with the greatest of care. A hard knock against a rigid surface can cause severe, and possibly irreparable, damage to a lens or camera. In sum, if you take good care of your zoom lens and protect it well at all times, it will take care of you with a perfect and consistent record of performance.

The invention of the zoom lens marks the beginning of a new era in photographic optics. It is reasonable to assume that zoom lenses will soon replace the normal lenses to which we have been accustomed for decades. While normal lenses may have higher light-gathering power (a larger maximum aperture), this advantage is being eroded with the progressive increase in film speeds. While zoom lenses cost more than normal lenses, their remarkable capabilities in terms of convenience and ease of use, and in particular their astonishing versatility, outweigh their expense.

After over forty years of experience with 35mm cameras, I have only one final word to say about today's zoom lenses: *Recommended!*

TIBURON

Tiburon, California, a residential community on the shores of San Francisco Bay that is well-known for its pictorial attractions and its unique charm, is visited annually by many tourists who enjoy its quiet ambience, its variety, the sunny decks of its few restaurants, its architecture, and its history. Most visitors to Tiburon bring their cameras, and today their zoom lenses. I thus selected Tiburon for this brief photoessay, which shows what a hypothetical tourist equipped with a 75–205mm zoom lens might

take home as his or her record of Tiburon as seen by the observant eye.

Most of the paired photographs that follow were deliberately taken at only two focal-length settings—the minimum of 75 mm and the maximum of 205 mm. But in examining and comparing the photographs, remember that with a zoom lens, you could just as easily use any focal length between the minimum and the maximum to suit your personal preference as to composition and content. The close-up and macrophotographs were made in accordance with the dictates of the subject matter.

This group of photographs will serve, at best, to demonstrate the remarkable control over pictorial content that a single zoom lens with macro capability can bring within your reach.

FIG. 15-1. Bus stop. Focal length used: 75 mm.

FIG. 15-2. Bus stop. Focal length used: 205 mm.

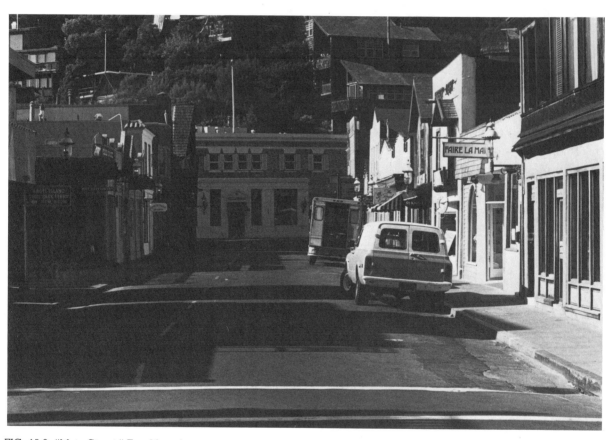

FIG. 15-3. "Main Street." Focal length
used: 75 mm.

FIG. 15-4. "Main Street." Focal length
used: 205 mm.

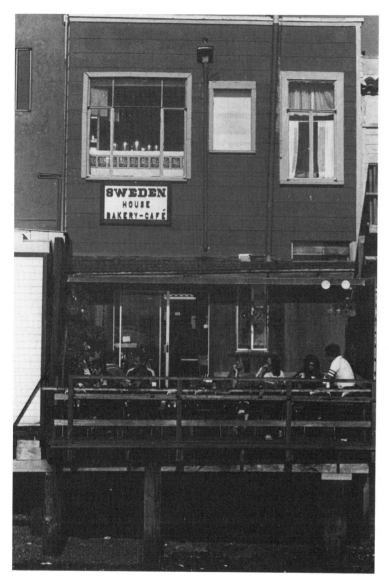

FIG. 15-5. Dockside restaurant. 75–
205mm zoom lens set at its 75mm
focal length.

FIG. 15-6. Upper details of the
dockside restaurant building made
with a 75–205mm zoom lens at its
205mm focal length.

FIG. 15-7. The deck of the dockside
restaurant shown in Figure 15-5,
made with a 75–205mm zoom lens at
its 205mm focal length.

FIG. 15-8. Cup shelf. Focal length
used: 75 mm.

FIG. 15-9. Cup shelf. Focal length
used: 205 mm.

FIG. 15-10. St. Hilary's Church. Focal
length used: 75 mm.

FIG. 15-11. St. Hilary's Church. Focal
length used: 205 mm, plus 2X tele-
extender for a focal length of 410 mm.

FIG. 15-12. Flowerpots. 75–205mm
zoom lens set at 75 mm.

FIG. 15-13. Flowerpots. 75–205mm
zoom lens set at 205 mm.

FIG. 15-14. Anchor. 75–205mm zoom
lens set at 75 mm.

FIG. 15-15. Close-up of anchor collar,
shackle, and chain. 75–205mm zoom
lens set for macro range.

FIG. 15-16. "Breakfast portrait." 75–
205mm zoom lens set at 75 mm.
(Photo courtesy Christina Gratzer.)

FIG. 15-17. "Breakfast portrait." 75–
205mm zoom lens set at 205 mm.
(Photo courtesy Christina Gratzer.)

Index

Index prepared by Lisbeth Murray.

About the Author

William Hawken has extensive experience both as a practicing photographer and as a teacher. He has been head of the Library Photographic Service at The University of California at Berkeley and a consultant to the American Library Association on document reproduction. His publications include the highly successful *You and Your Camera*, *You and Your Lenses*, and *You and Your Prints*, and his latest book, *Close-up Photography*.

California rural architecture—the author at work. (Photo courtesy of David Garratt)